ILLUSTRATION PHOTOGRAPHY

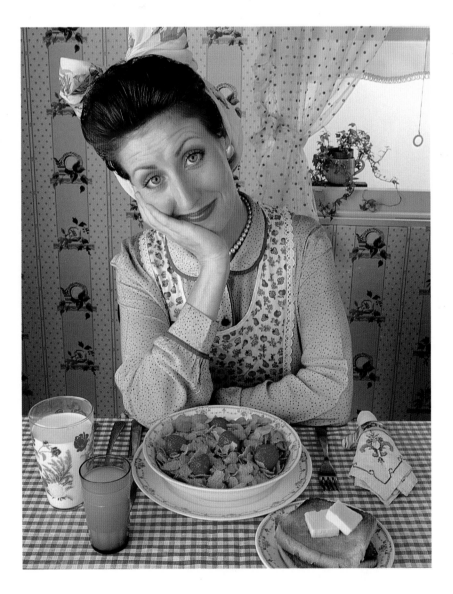

To Michael,
Best wishes and
happy Reading.

ILLUSTRATION

PHOTOGRAPHY

Jack Reznicki

AMPHOTO
AN IMPRINT OF WATSON-GUPTILL PUBLICATIONS
NEW YORK

Copyright © 1987 by Jack Reznicki

First published 1987 in New York by AMPHOTO,
an imprint of Watson-Guptill Publications,
a division of Billboard Publications, Inc.,
1515 Broadway, New York, NY 10036

Library of Congress Cataloging in Publication Data

Reznicki, Jack.
 Illustration photography / by Jack Reznicki.
 Includes index.
 ISBN 0-8174-4010-0 (cloth). ISBN 0-8174-4011-9 (pbk.).
 1. Photography, Commercial. 2. Photography, Advertising.
I. Title.
TR690.R49 1987 87-16102
778.9'97416—dc19 CIP

Manufactured in Japan

1 2 3 4 5 6 7 8 9 / 95 94 93 92 91 90 89 88 87

Editorial concept by Marisa Bulzone
Edited by Robin Simmen
Designed by Jay Anning
Production by Hector Campbell

To my father, Zalman Reznicki

I would also like to thank the following people
whose help and support made this book a reality:
Regina Riesenburger, Marisa Bulzone, Robin Simmen, Jay Anning, Elyse Weissberg,
Robert Dutruch, and Bruce Wodder.

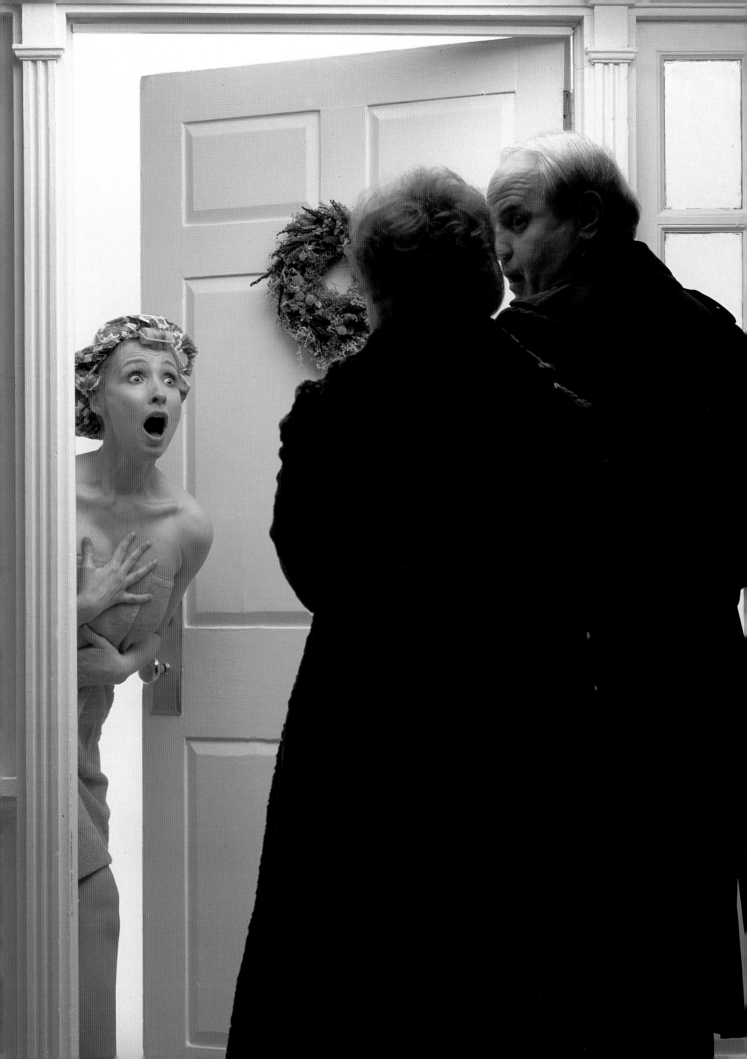

CONTENTS

INTRODUCTION

*The difference between a good photograph and a great one
is the difference between a lightning bug and lightning.*
—with apologies to Mark Twain

Ninety percent of a great photograph is preplanning.
—Jack Reznicki

When the great Russian general G. A. Potëmkin decided to travel through a certain district in 18th-century Russia, the villagers rushed to spruce up the villages along the way. That is quite an understatement. What they actually did was create villages that existed only for General Potëmkin's eyes. It was an enormous undertaking. Everyone pitched in. Merchants closed their stores, peasants came in from the fields. New buildings went up, but only the fronts. False spires were added to spireless buildings. Walls were painted, loose boards were nailed down, new curtains were hung, the streets were cleaned, the town drunk was sobered up, diapers were put on the horses—it was pandemonium. After many weeks of work, the villagers stepped back and admired their efforts. They had done well. All of these "Potëmkin villages" were finished, and not a moment too soon.

Just as the last flag was raised, the moment was at hand. The trumpets blared, the crowds cheered, the dogs barked in the cages where they were penned up. The great Potëmkin was arriving. And the great Potëmkin was leaving. General Potëmkin's great caravan went through the villages and never stopped. He wasn't meant to. The villages had only been fixed up for him to view as he rode past. As soon as he left, everything went back to normal. The merchants opened their stores, the peasants went back to their fields, the sobered-up drunk went back to his bottle, and the dogs were uncaged.

To understand the general idea behind this book on illustration photography, imagine that Russia is a photo studio, the general is an art director, and the village drunk who quickly cleans up his act is the photographer. As a photo illustrator, I am basically a creator of Potëmkin villages, but my villages are usually built with a dose of Norman Rockwell, a dash of Frank Capra, and, I hope, a large pinch of Charlie Chaplin.

When a layout, or a job, comes into my humble studio, the great frenzy begins. People are called in, budgets are approved and etched into stone, sleeves are rolled up, false fronts are built, objects that haven't seen a paintbrush in years are painted or spray painted. An illusion is created. It's lit and preserved on film, and then we dispose of it. It's all over in a flash (so to speak).

The type of photography I do is called photo illustration. "Illustration" refers to the fact that I am asked to illustrate a specific idea or mood for an advertisement by means of my photography. In the past, this work was done by artists, such as Peter Helck, J. C. Leyendecker, and Norman Rockwell. Today it is usually done by photographers.

The difference between a people and portrait photographer and a photo illustrator is similar to the difference between a documentary film and a feature film. The former is a record of what is observed, and the latter is an observation created. I am more interested in the perception created than in what actually ex-

ists. I'll repeat that last thought for all you speed readers, since it's a very important concept in illustration photography. *The perception created in the photograph is more important than the reality of the situation being photographed.* This is sometimes a very hard concept to get across to inexperienced clients.

I have to work in a visual shorthand, photographing a scene that is a quick "read." Everything I need to tell the "story" of the photograph has to be right there. The story cannot be too abstract or deep but must be right there on the surface for the viewer to see or relate to. For example, I've photographed many grandmothers with their hair in a bun and a cameo around their necks. Believe me, this is not what most grandmothers really look like today, but rather the popular concept of what a grandmother should look like. However, there is no hesitation on the viewer's part about what they're looking at—it's a grandmother. In photo illustration, it's my perception of reality that I photograph, not reality itself.

As another example, many of the young-mother-type models I photograph maintain a working wardrobe of young-mom clothes. For some of them these are not the type of clothes they prefer to wear, which are very trendy or faddish, but a professional wardrobe of plaid blouses and solid skirts that look like the clothes advertisers use in young-mom commercials. These models may be young mothers in real life, but they know I'm interested in the general public's perception of what a young mother looks like, not in what may be the reality.

When I receive a layout for an ad from a client, be it a rough thumbnail sketch or a complicated, detailed drawing, my job as a photo illustrator is to breathe life into that two-dimensional layout and make it readable to the viewer. In the course of this book, I will show you layouts of ads I have shot, along with the final photographs, so you can see a concept as it is presented to me and what I do with it.

What makes my work different from someone else's? I'd have to say, my emotions. Anyone can learn the mechanics of photography. The cameras, the lenses, the films, lights, props, models—they are all just the ingredients. The exact same ingredients are available to anyone. It's how you mix them together that makes the difference. Just as two different chefs can create different-tasting soufflés using eggs from the same hen, or two conductors can create different effects from the same symphony, so different photographers create different photos using the same layout.

What clients look for when they ask me to illustrate their ad, or layout, is the emotional content and natural look of my photos. Even when I was about thirteen years old, one of my favorite hobbies was to pick a street corner in the downtown section of my hometown, Rochester, New York, and sit for several hours watching and photographing as people went by. In

HAPPY BIRTHDAY GRANNY!

The model in this photograph is Loretta Tupper, the quintessential, feisty grandmother who often appears on television. Her feistiness is no act—she is just full of spit and mischief, a very interesting character who is much loved in the business. I made this shot for a medical account illustrating how modern medicine enables people to live longer.

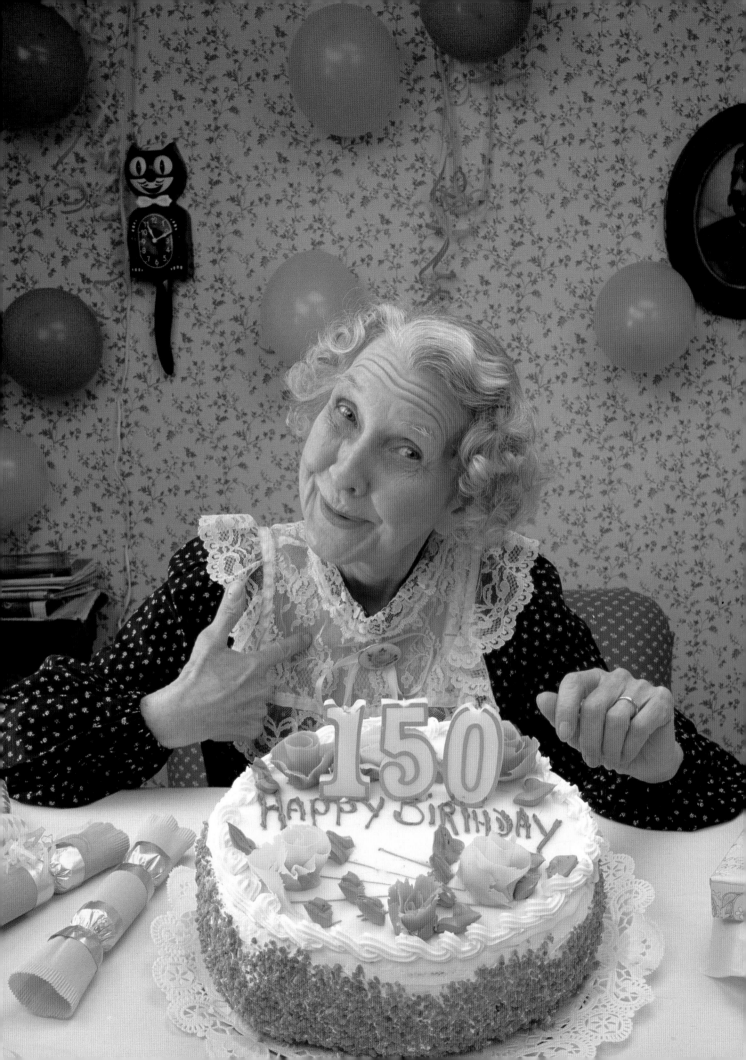

that time I might shoot five frames or five rolls of film. Even then, I looked for the emotion, the story told by a single image. I was constantly fascinated by the people going by. To this day, nothing intrigues me more than just watching people. I love going to country fairs, pancake breakfasts at a small-town firehouse, or just a street in New York—not to take pictures, but just to watch. To me, taking pictures is just the mechanical part of watching.

Sometimes, taking pictures can get in the way of watching, but usually taking pictures makes me see things in a different context or from a different point of view. Once when I was in Paris, it started to rain. I grabbed my camera and ran out to take pictures in the rain so I could catch the beauty of Parisian lights shimmering on the wet pavement. If I hadn't been a photographer, I would have stayed indoors.

Please note that when I say "taking pictures," I don't mean creating an illustration. To me taking pictures for myself is a busman's holiday. My personal photos constitute a special notebook on people watching. Making these pictures is a training process, somewhat like a boxer doing roadwork to build up his stamina. These pictures all have an influence on my professional work. I'm also a sucker for films by such people as Frank Capra and William Wellman, films from the 1930s and 1940s. Their use of stereotypes and emotions in telling a story has always fascinated me.

This book will, I hope, explain to the reader and to my mother what I do for a living. I will try and explain the thought process and the preparation that goes into creating a photograph. Actually taking a photograph is about 10 percent of what I do. It's the fun 10 percent, but I can't get there without going through the other 90 percent first. Like the Potëmkin villages, this work is not a one-man operation. It takes a lot of people to produce the photo illustrations that I create. There are, for example, location scouts, assistants, set builders, prop stylists, makeup artists, and messengers, and their work has to be coordinated. There is a lot of behind-the-scenes work.

Ancient Korean potters were known for the exceptionally fine glazes on their pottery. The colors had a richness and a depth that was unmatched. They achieved these colors by meticulously applying several undercoats of glaze that were not necessarily the same or similar to the color that was finally applied. By providing the final glaze with a rich base, a base that was never seen, they were able to achieve a beautiful effect.

Today's commercial photography is much the same. Most of what is done is under the surface. Without careful preparation you cannot make a beautiful finished product. To get that great photograph, it's the undercoat, the work done behind the scenes, that gives the picture its depth and richness. Often a little luck doesn't hurt either.

I hope this book will clarify some of the thought processes and preparation that go on before and during a shoot. The next time you have to create a Potëmkin village for a photograph, you will have some idea of how to do it and what pitfalls to avoid. As you will see, most photographs are not taken but rather are built.

LEARNING TO LOOK

One of the best exercises for a photographer is simply to observe other people. Being a photographer means being a voyeur. Often I see people do things that are too quick to record with my camera, but I'll remember the moment and use it as a basis for deciding what looks natural in a photograph.

I photographed the beer vendor and the baseball pitcher when I was 16 years old after having observed both of them for a while. I was working for the Rochester Red Wings, the local baseball team in Rochester, New York, my home town. These are two of my favorite shots from that time. They are both directed shots. I knew the beer vendor, and I had him pose for me. I photographed the pitcher on his practice mound. I had been watching him for a while, and I photographed him without using a motor drive during different points in his delivery of the ball.

I also shot the motorcycle and the bus when I was a teenager. Those were the days of one camera, one lens, and one film—Kodak Tri X. Not having a lot of equipment enabled me to concentrate on looking and taking pictures without too many technical distractions.

The little boy getting his haircut was photographed after I had opened my studio in New York. I had gone down to Eufaula, Alabama, and I captured this moment as I was walking down the street taking in the sights. I'm thankful I had my camera because there in front of me was a simple, everyday ritual that people everywhere recognize—a boy getting his first haircut.

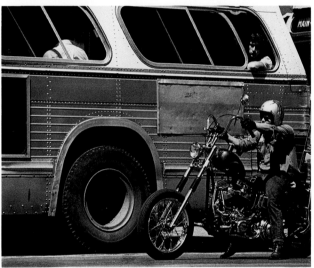

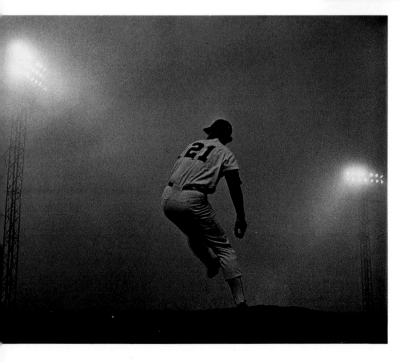

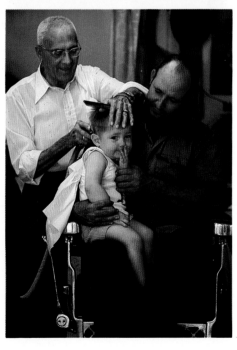

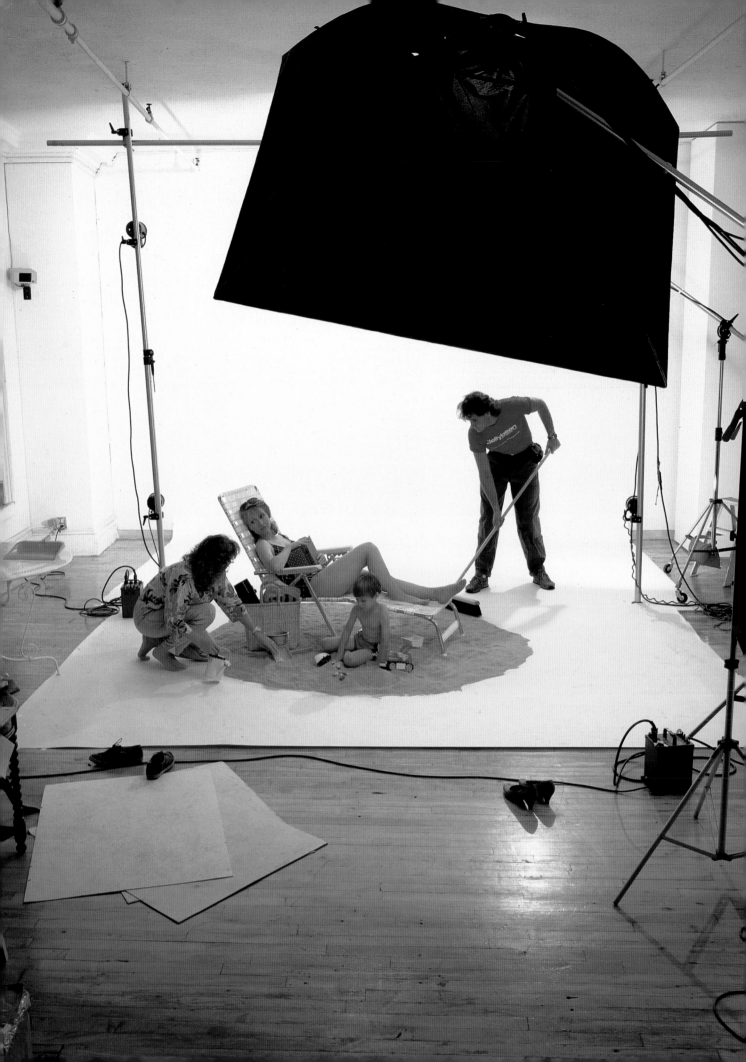

THE STUDIO

Reality is not all it's cracked up to be. What looks good in real life doesn't necessarily look good on film and may not be practical or possible to photograph. The first part of many assignments is deciding how to fake something and still make it look realistic to the camera. Everything I do is for the camera's eye and from the camera's point of view. Sometimes I have to go on location to achieve a certain realistic look. Sometimes I have to stay in the studio to have the control to achieve the level of realism I need. There are many factors that determine where I ultimately shoot—the budget, the weather, the logistics, any number of things.

My studio is my own little universe, where I am in total control. It's a void that I can fill with my own vision of what should be—a beach, a backyard, a medieval alchemist's room, a middle-American living room, a bathroom, outer space. I can control the weather, rain or sunshine, and the time of day, morning light or evening darkness. I am the center of this universe called my studio. It sounds very egotistical, doesn't it? Well it has to be. It takes a lot of money and energy to run a studio—rent, payroll, insurance, equipment, repairs, messengers, portfolios—it never ends. On the set, the models cost $250 an hour plus. One little day in my universe may cost $5,000, $10,000, $20,000, or more to produce, and if I go past the time allowed, the meter keeps running to the tune of several hundred to several thousand dollars every hour. Yes, it does take a bit of an ego, but running an illustration studio is no place for a shrinking violet.

DIMENSIONS AND PRIORITIES FOR WORKING SPACE

A studio should be at least wide enough to accommodate an extra-wide roll of seamless paper (12 feet, or 3.6 m) or three 4-foot (1.2 m) flats (see "Building a Set") side by side, as well as 3 feet (0.9 m) on either side for lighting equipment, which means a total minimum width of 18 feet (5.5 m). A studio should be long enough to shoot a person full-length with a moderately long lens, such as 105mm lens on a 35mm camera or a 150mm lens on a 2¼-inch square camera. (That allows enough room to build a 10-foot (3 m) wall and have a little bit of room above to work and place a light. Again this is a minimum. The higher the ceiling the better. My first studio had 16-foot (4.9 m) ceilings. I loved it.) The ceiling height should be at least 11½ to 12 feet (3.6 to 3.7 m). Of course, that is the minimum-size room to look for.

If circumstances allow, a football field with four walls and a roof is preferable. I have never heard of a photographer complaining about having too much space to shoot. It seems as if photographers are always backing up against a wall to shoot. I know that even if my studio were the Astrodome, I'd still be backing up against the wall.

In addition to the studio area, where a photographer actually shoots, it is very helpful, and sometimes essential, to have other rooms available for various purposes. Studio layouts vary from photographer to photographer, but they usually include some combination of the following rooms.

A waiting room. Clients, parents of child models, and any other people who aren't needed on the set during the actual shoot should be seated off set simply to keep distractions to a minimum. After seeing other photographers' studios without waiting rooms for clients, I tend to think this type of room is a must. A photographer also needs to have telephones available for clients. If it is possible to get telephones that can be programmed so

that no one can make long-distance calls, the photographer will be better off. Art directors aren't too bad, but the account people often seem to know a lot of people out of town.

A darkroom. If there are good labs and printers around, I would say a darkroom is not a must, but personally I have to have one, especially when my deadline for getting a print to a client is overnight. Because of the constant turnover in personnel in this business, I have found that to insure consistency in my black-and-white negatives, it is best to send them to a lab and do the contact sheets and prints in my darkroom. Because all my black-and-white work is on 120mm film and has to be processed in deep tanks due to the large number of rolls I shoot, I have had problems with assistants not agitating the chemicals correctly. As a result, I found I was getting a surge of development on the edges of my film and mottling on my backgrounds. Now I closely monitor this aspect of darkroom work in order to achieve consistent results.

Dressing room. If necessary, a darkroom or bathroom can be used as a dressing room. For fashion photographers I would say having a dressing room is a must.

Casting room. It is not mandatory to have a casting room, but a photographer should plan where to have a casting if he or she also has to shoot on the same day.

Office. A photographer definitely needs a room to do paperwork and collect his or her thoughts.

Storage and prop room. Although a storage room is not really a necessity, it is awfully hard not to be a pack rat in this business, considering all the useful props one is likely to run across.

Kitchen. A kitchen is useful only if the photographer shoots food or wants to have a place to prepare snacks for clients.

Workroom. A place to do all the cutting, painting, and other messy work and to keep tools is very nice to have if there is space for it.

The layout of the studio is very important. Think about the traffic pattern through a studio. How do people move

through it? Does the client have to go through the set to reach the front door? Can a model in a bikini go from the dressing room to the set without going through a casting session for 12-year-old boys?

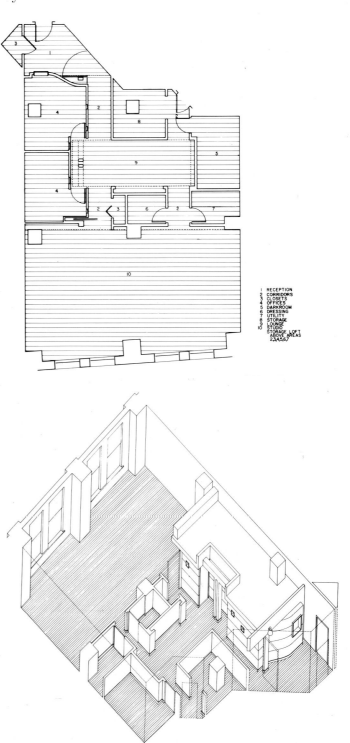

1 RECEPTION
2 CORRIDORS
3 CLOSETS
4 OFFICES
5 DARKROOM
6 DRESSING
7 UTILITY
8 STORAGE
9 LOUNGE
STUDIO
10 STORAGE LOFT
ABOVE AREAS
2,3,4,5,6,7

These are the blueprints for my studio designed by Robert Tan, a very talented architect. Because I knew what I wanted and I worked with a professional, I now have a studio that is beautiful as well as very comfortable to work in.

STEPPING BACK IN TIME

I love recreating different eras in the studio. Looking for period props is a great excuse to go knocking around flea markets. The radio, the doilies, the Hummellike figurines, and the hook rug in this thirties set are all from my own prop closet. I used genuine antique wallpaper, and it was a terror to put up—there wasn't any pre-trimmed, prepasted, or vinyl wallpaper in those days. I always use a lot of diffusion and yellow filters when shooting period pieces in order to give them an old, faded-photograph look.

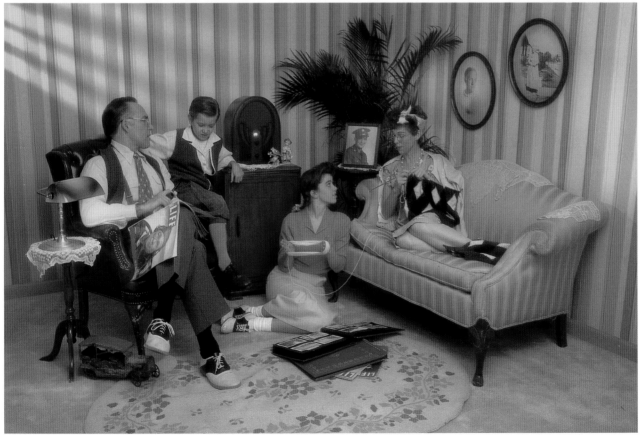

SUNSHINE ALL THE TIME

It's very hard to shoot a beach scene in Manhattan in January, but I sometimes have to do that in order to make a deadline so the client can insert his or her ad that spring or summer. It's nicer to be able to go to Florida or the Caribbean if the budget allows it.

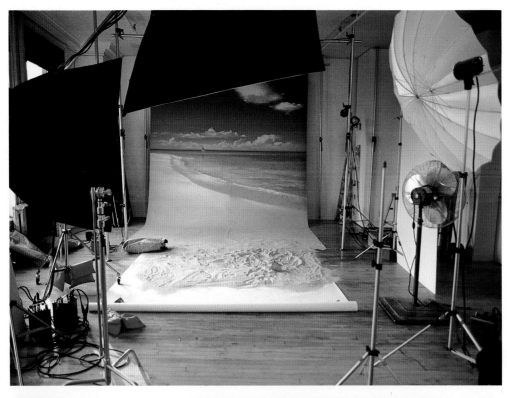

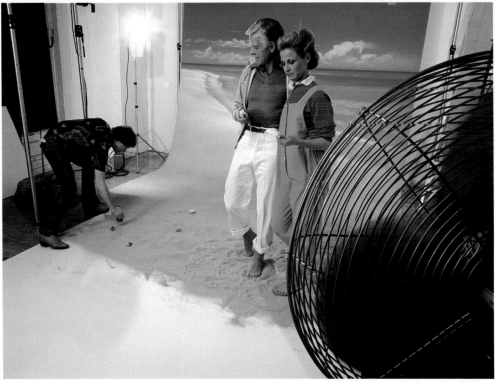

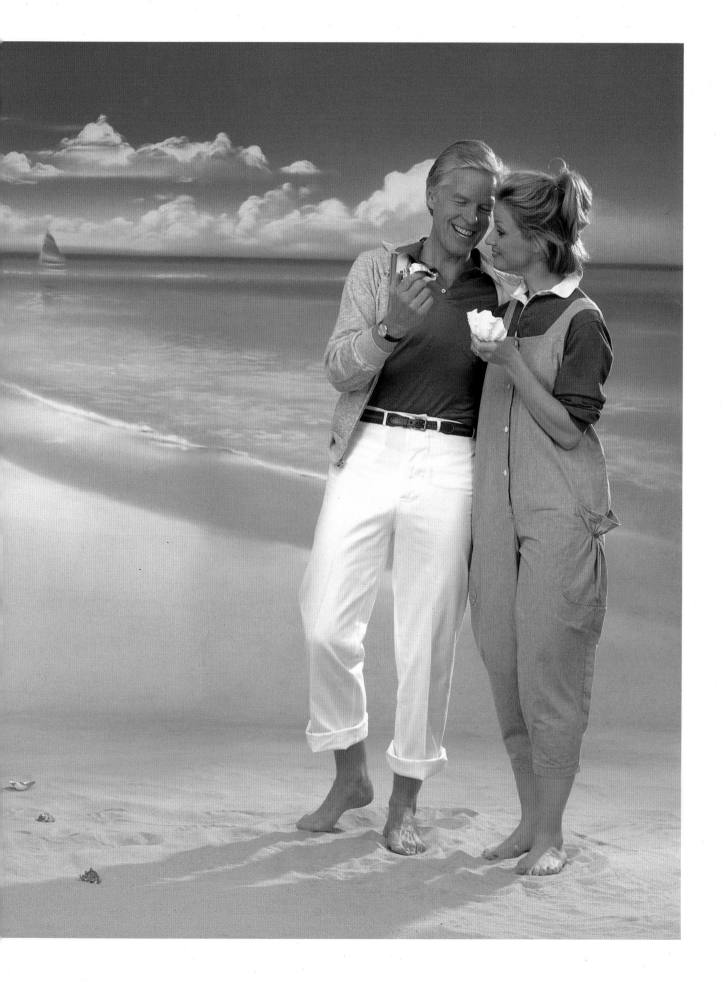

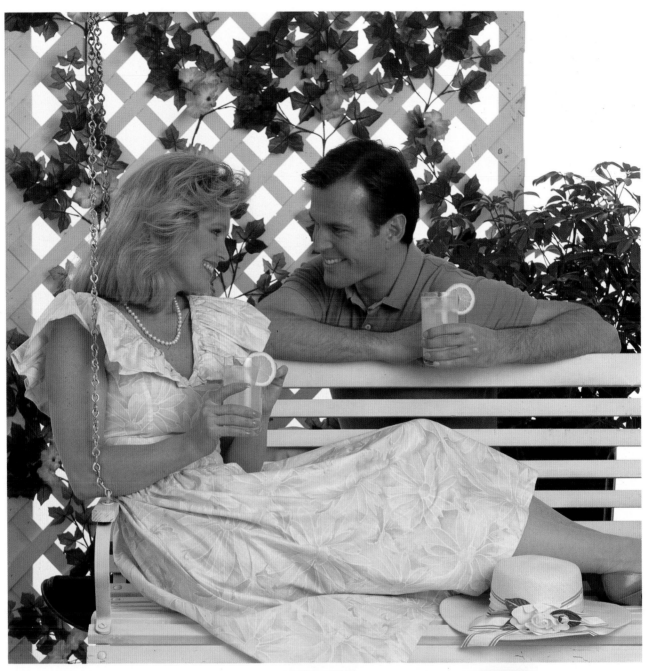

A SUMMER SCENE

I created this summer scene in January in my studio. The hardest part was hanging the swing so that it could support a person. Ultimately, I didn't hang it after all; instead, I set it on apple boxes because the art director decided to crop out the area beneath it. Even so, I covered the apple boxes with white cards because I like to give the art director a chrome that is as clean as possible.

THE STUDIO ON LOCATION

There are times when I have to set up a studio situation on location. Every time I leave the place I call my studio, I lose a certain amount of control and add an amount of the unexpected. Once while changing planes in Chicago for an assignment in Eugene, Oregon, I happened to look out the window of the plane as we were pulling out of the gate, and there on the tarmac was my equipment in a baggage handler's cart. After a frantic discussion with the head stewardess ("Are you *sure* that's your luggage?"), the plane pulled back into the gate. It's amazing how persuasive one can be upon realizing that Eugene, Oregon, will not be a hotbed for renting photographic equipment needed to shoot a particular ad.

I may opt to shoot on location for one assignment for the same reason I may choose to shoot in my studio for another assignment. If that sounds confusing, it is because each and every assignment has its own specifications, realities, and peculiarities. The exact placement of a model in relation to a window or door may determine that that job has to be shot in a studio where a set to create that relation can be built.

Sometimes it's the budget that determines whether a shot will be done in the studio or on location. A living room set with a wallpapered wall, a rug on the floor, and a couch may be less expensive and just as real looking as a living room on location. Then again, it may not, depending on the look I want.

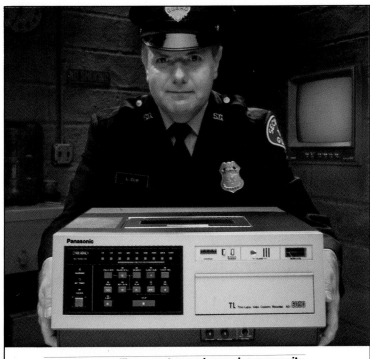

Specifically designed to make your security system more secure. The Panasonic NV-8050 time-lapse VCR.

WHEN FAKE IS BETTER

The shot of the security guard holding a Panasonic VCR had to be taken in the studio because of the importance of having the monitor on the right side mounted on the wall. I could have found a great location, but I would not have been able to mount the TV monitor on the wall. Looking at the layout, one can see that no wall or props have been drawn in. If I had shot the ad to look that simple and stark, it would have looked like a faked studio shot. That was not what the client wanted. The cinder blocks are actually horizontal plastic sheets, 4 × 10 feet (1.2 × 3 m) molded from a real cinder-block wall. The sheets are stapled onto flats and painted gray. Notice how I used generic patches and badges on the guard. Using a real security company's name on the patches could have created a legal problem.

AN OFF-KILTER AFFAIR

It really didn't matter where this shot was set up, in the studio or on location. The art director decided to shoot on location at her home to avoid the cost of building a set. The only problem I encountered was disguising a central air duct on the left side of the shot—I hid it with the bunch of balloons.

Everything in the shot was set up for correct perspective through the camera lens. The table was actually very close to the wall, and the people were scrunched together, but through the lens the scene appears to be very spacious.

Some of the food-laden plates were tilted up toward the camera by wedging coins and folded pieces of cardboard beneath them. This way the food was more visible. In such table-top situations, objects don't have to be tilted much—just a little bit helps. Too much tilt can make them look cockeyed. Tilting objects also helps to correct the distortion that occurs at the edge of the picture frame when using a wide-angle lens.

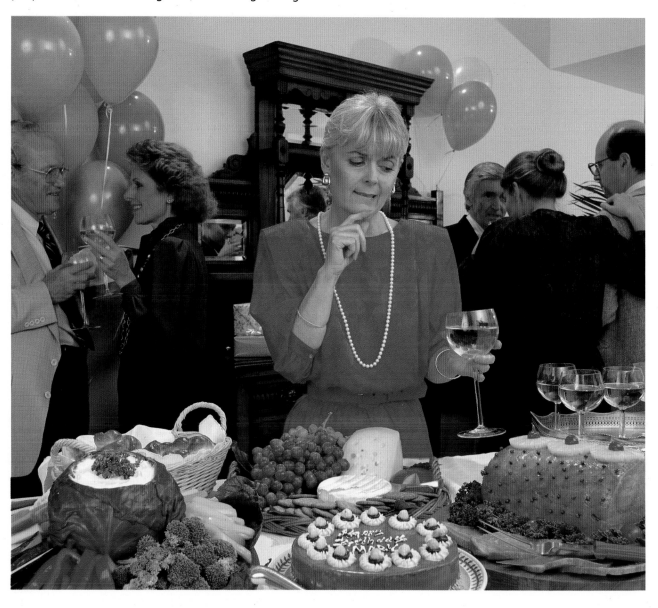

A COST-EFFECTIVE SET

Supermarket aisles can easily be created in the studio. All I need is gondola shelving and a tile floor, both of which are easy to rent. It's what I put on the shelves that sends the cost into the stratosphere. (Consider how few items it takes to fill a grocery bag and and how much they cost.) Whenever I see a layout where the shot must be in a supermarket, I know the odds are that I will be getting up at some horrendously early hour in order to shoot in a supermarket before it opens. Then again, I have received layouts that were so specific about what the ad wanted that I had to shoot the sets in the studio.

In this case, I had to shoot after the supermarket opened with people shopping all around me. Most of the shoppers were oblivious to the shooting session—they had to do their morning shopping.

EQUIPMENT AND FILM

I use a Hasselblad camera for most of my work. The Hasselblad is a workhorse of a camera, built to take a lot of heavy use. Because most of the photographs I take are planned shots, I usually have the luxury of shooting with a tripod. (If I am shooting something that is constantly moving—such as a rodeo for Wrangler jeans—or that is more reportage in feeling—such as an Army shoot—I switch to 35mm.)

I like the Hasselblad's 2¼-inch square format, but it isn't ideal for most situations. How often does someone ask me to shoot a square photo? Usually my clients want a horizontal or a vertical. With Hasselblad's format I waste a lot of film around my subject. I've had several friends switch to 6×7mm cameras, the so-called perfect medium format. The 6×7mm format, with a rotating back for shooting horizontally or vertically, allows a photographer to utilize more of the film without enlarging the image as much as is necessary for a horizontal shot from a 2¼-inch camera. However, I have watched these friends consistently take their cameras in for repairs or for slight modifications, such as strengthening weak camera parts.

When I first bought my 2¼-inch camera, it was one of the few cameras that could adapt for taking Polaroids simply by changing the camera back. The fact that I've invested a lot in a system (camera and accessories) that I am comfortable with makes me reluctant to switch to a new system, which would be uncomfortable because it would be unfamiliar at first. I am also reluctant because of the high cost of replacing not just one but two of everything, since I am a firm believer in owning backup equipment. As of this writing, Kodak has announced the appearance of 120mm Kodachrome film. I hope this means a new interest in medium-format cameras and some new designs in camera manufacturing.

So for now, I am the owner of a system that is very expensive and does not have a format that thrills me. But as a professional, I have to weigh the pros and cons. I am also the owner of a system that is excellent, well designed, and able to take a lot of abuse. A camera doesn't make or break a photographer; there are many other tools of the trade that are essential. Here is a basic packing list of the accessory equipment that goes with me on location jobs:

Tripods—a Gitzo Tele Studex Compact/ Cremaillere that has four sections and extends from 25–78 inches (64–198 cm) in length; and a Gitzo Tele Studex Giant/ Cremaillere that has five sections and extends from 28–116 inches (71–295 cm).

Electronic Flash—Dynalite strobe units. My strobe accessories include: umbrellas, diffusion material, colored gels, barndoors, angle reducers, grid spots, extension cables for the strobe heads, slave units, sync cords, and PC cords.

Stands—Bogen super booms, portable booms, 12-foot (366 cm) stands, 8-foot (244 cm) stands, a pic stand, floor stands, and Bogen auto poles.

Sandbags—portable Matthews sandbags with zippers (I get sand and dirt to fill them on location, usually at a garden center where sand is really cheap or at the beach where it's free), and regular, non-zippered sandbags for the studio or nearby locations.

Meters—a Minolta Flash Meter III for strobe and ambient light; and a Minolta Color Meter II for color temperatures.

Filters—Kodak color correction (CC) filters, 81-series filters, and various adapters for diffusion material.

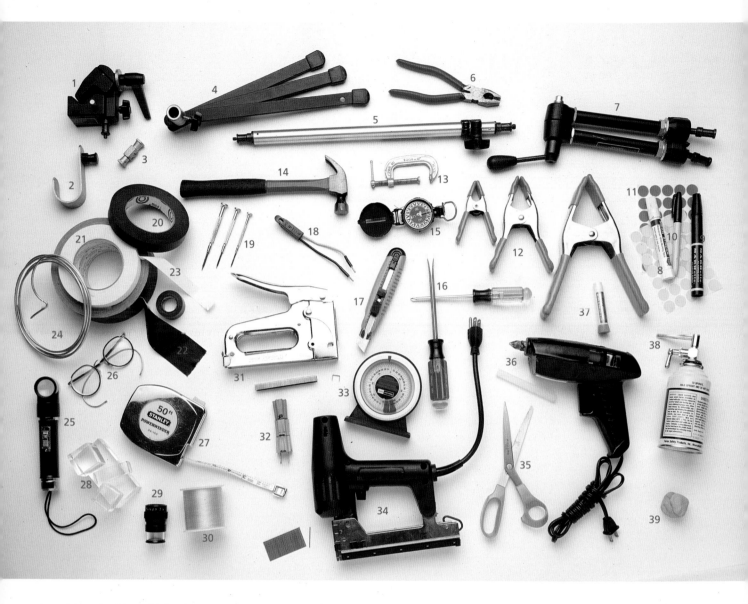

My grip kit, which always goes on location with me, includes:
1. Super Clamp with stud
2. J-hook for Super Clamp
3. Stud to hook two Super Clamps together
4. Floor stand
5. Extension for floor stand or Super Clamp
6. Pliers
7. Bogen Magic Arm
8. Mean Streak white marker
9. Marks-a-lot black marker
10. Sharpie black marker
11. Colored labels for film

12. A-clamps
13. C-clamps
14. Hammers
15. Compass
16. Screwdrivers
17. Mat knives
18. Electrical current tester
19. Jeweler's screwdrivers
20. Black tape
21. White tape
22. Gaffer's tape
23. Electrical tape
24. Armature wire
25. Lupe with built-in light
26. Extra pair of glasses

27. Measuring tape to check focus
28. Acrylic blocks for supporting props
29. Lupe
30. Monofilament
31. Staplegun and staples
32. Three-to-two-prong converters
33. Protractor to level camera
34. Brad gun and brads
35. Scissors
36. Hot-glue gun and glue stick
37. Super Glue
38. Canned air
39. Fun Tack

Grip and miscellaneous equipment—Bogen Super Clamps, A-clamps, C-clamps, Bogen Super Arms, armature wire, monofilament, Fun-Tac putty, three-prong-to-two-prong electrical adapters, a hot-glue gun, a brad-nail gun, a stapler, a hammer, wrenches, screwdrivers, extension cords, 30×40-inch (76×102 cm) silver cards, matt knives, gaffer tape, black tape, white tape, and apple and pancake boxes (wooden boxes of different heights to prop up people and objects).

RENTING EQUIPMENT
Photographers who are just starting out need only a basic amount of equipment—it is wise to borrow or rent the rest. By a basic amount, I mean equipment that will be used often, not just every once in a while. When I first started my studio, I already owned a 35mm system that I had in college—a Nikon F2 body, a Nikkormat body, two wide-angle lenses, a normal lens, and one telephoto lens. Then I bought my Hasselblad system consisting of one body, one lens (the normal 80mm), two film backs, and a Polaroid back. My lighting equipment was one 800 W/S strobe unit and two heads for it. It was not enough equipment to shoot a lot of the jobs that came my way, but it was basically what I needed. Every time a job came in that required more, I was able to borrow equipment from friends, rent equipment on account, or buy a piece of equipment I needed for that job (and hope I was paid before the bill came due; it pays to have a good relationship with the suppliers that extend you credit).

Whether I rent or buy a piece of equipment depends on how often I'm going to use it. If I'm going to use it only once or twice a year, I think it's smarter to rent it. A $2,000 lens that I use only twice a year may rent for $100 per day. That means I can rent the lens for many years before I use up what would have been the purchase price. In the meantime, I've saved that money to spend on another piece of equipment that I use more often. (Admittedly, it is hard to resist buying a lens when it sits there in the dealer's case looking very seductive, just calling out my name. So much for logic.) In addition, the cost of renting some specialized piece of equipment can be passed on to the client.

LEARNING TO IMPROVISE
Sometimes I discover too late that I don't have a piece of equipment I need for a shot. Then I get to prove how good I am at improvising. A Bogen Super Clamp fitted with a ball head to hold the camera can clamp to almost anything and enables the camera to be secured when placement of a tripod is impossible. Gaffer tape (or its more inexpensive but harder-to-use cousin, duct tape) is one of the all-time great improvising tools. It's great for ensuring that any number of things don't move when they aren't supposed to move. For example, gaffer tape can be used to

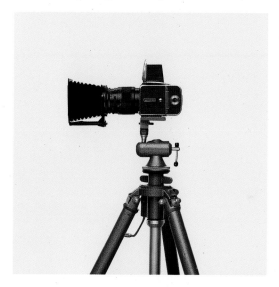

My Hasselblad camera is shown here mounted on a Gitzo Tele Studex Giant/Cremaillere tripod.

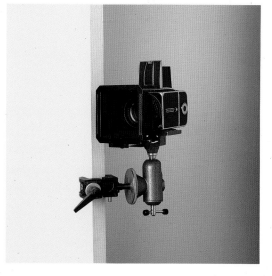

When using a tripod isn't feasible, I can still mount my camera on a ball head attached to a Bogen Super Clamp and anchor it on a wall.

27

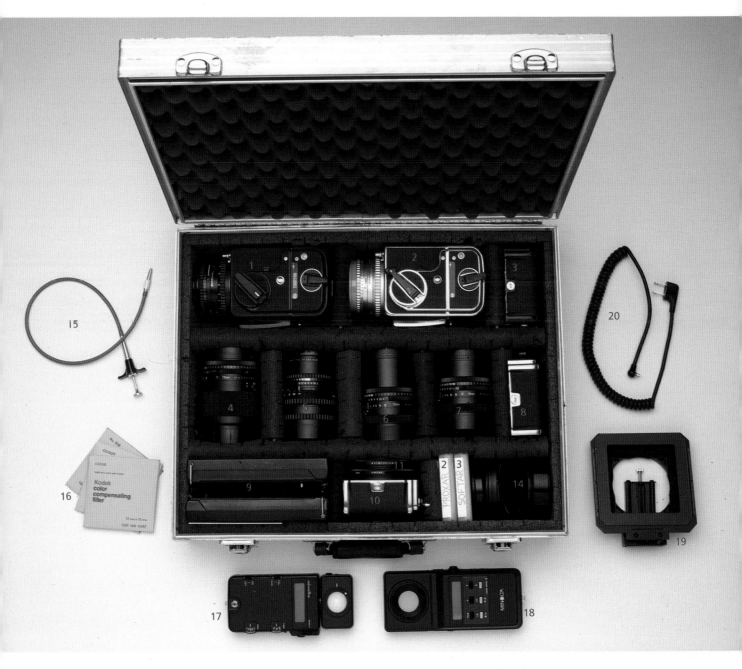

I carry the following equipment in my camera case:

1. Hasselblad body, 80mm lens, film back
2. Hasselblad body, 80mm lens as backup; second film back
3. Third film back
4. 120mm lens
5. 150mm lens (two telephoto lenses in case one breaks down)
6. 50mm lens
7. 60mm lens (two wide-angle lenses in case one breaks down)
8. Fourth film back
9. Two polaroid backs (one for color, one for black and white)
10. Fifth film back
11. Gel holders and lens adapters
12. Proxar close-up filter
13. Softar-diffusion filter
14. Various filter adapters
15. Cable release
16. CC and warming filters
17. Minolta exposure meter for strobe and ambient light
18. Minolta color meter (flash attachment not shown but it always travels with me in another case)
19. Lens shade and filter holder
20. PC cords.

tape down extension cords on location so people don't trip over them. When I loop it around in a tube, I have instant double-stick tape for keeping someone's shirt collar from sticking up. When I roll it up in a ball with the sticky side out, it can be used to prop an object,on a table or angle a picture on a wall to reduce glare. It is one of the best lint-removing tools around, and it can even be used to hem a skirt. (The more I talk about gaffer tape, the more I feel I'm doing a commercial for a Ronco product on late night TV: "Yes, folks! A thousand and one uses, only $14.95.") The real beauty of using gaffer tape is that whatever is taped stays taped.

There are a few other tools that I find invaluable in improvising or helping solve problems that arise unexpectedly. Armature wire and monofilament are always lifesavers (for specific uses, see "Rigging the Set"). A hot-glue gun is also a terrific tool to have around the studio for attaching an object to prevent it from moving. Hot-glue guns are available at almost any hardware store; it is worth it to buy one with a trigger feed although they cost a little more than a thumb-feed gun. Electric brad-nail guns are also a great hardware item. When I have to tack a piece of molding on a set or attach a piece of luan to a flat, a brad gun cuts the time I spend nailing by at least half.

I endorse the philosophy of economy that says, "Don't buy a battleship when you want to canoe up the river." Photographers don't always need the biggest, best, most deluxe pieces of equipment—they need whatever is most efficient. The best piece of equipment may be the cheapest in price, or it may be the most expensive. The trick to building a photography system that works is to use common sense.

FILM AND FILTERS FOR COLOR BALANCE

Because it is almost impossible to find a film that can be used as purchased, I test all my film to determine the correct filtration for the effect I want. The color film I buy right off the shelf is hardly ever neutral in tone, and the speed of a film may not be the same as the one advertised for that emulsion batch. A film that is supposedly ISO 100 could be in reality ISO 80 or 125. I buy film from the same emulsion batch in bulk, and then I run a test before using any of it.

I have my assistant pick up two rolls of whatever emulsion-number film my supplier has in large stock, which usually means two or three different emulsions. I use a standard lighting set-up for each test. My large bank is set off to one side so that the shadow of the assistant I am using in the test shot falls on a white card. I set up the card about 10 feet (3 m) from a white wall which in turn yields a very nice gray. This gives me all the information I am looking for: a skin tone, a gray, a white, and a shadow area. (My film tests always include skin tones because they are the most important tones in any of my shots.)

A lot of photographers seem to include a color-table chart in their color tests. I've never been able to read and extract useful information from photographs of these charts, so when I examine my test results, I just look at the color shifts in the gray and shadow areas. I correct the shifts to achieve neutral tones, and then I correct the color to get a pleasing skin tone. My test subject holds up a large piece of paper showing all the information I need for that frame of film: the emulsion number of the film, the filter being used, and the exposure range. I like doing it this way—later I can cut my film into strips without having to match each strip to separate film notes because the notes I need are on each piece of film.

I bracket my exposure one-half stop up and down to check the film's speed. The first three exposures I do are usually without any filtration, followed by three exposures with a warming filter, such as an 81B. Then I do three more exposures with a magenta filter and three more with a green filter. After I see these results, I test one more roll to fine tune my choices.

The film I use most of the time is Ektachrome 100 in the 120mm size. I like the control I have over its development—the lab can push and pull it in increments as small as ¼ stop. I also like the f-stops I can get with that speed and the way Ektachrome's color reproduces in ads. Kodachrome is my film of choice for 35mm

work and for my personal work because of its saturated colors and sharpness of image. But Ektachrome offers me more processing control; thus, I don't have to bracket and consequently lose shots that are under- or over-exposed. It's very disheartening to spend a long day shooting and then see that the best shot can't be used because it was taken at one of the bracketing extremes.

Ektachrome's colors, while not as rich as Kodachrome's, will reproduce better on a printed page. Kodachrome always seems to lose a lot in the translation from film to print. The reason is that printers have a nearly impossible time matching the rich color dyes used in Kodachrome with printer's ink. The dyes used in Ektachrome seem to be better suited to reproduction by a printer.

However, Ektachrome can be very blue. This tendency can easily be taken care of with a warming filter, such as an 81A, an 81B, or even an 81C color-conversion filter. Ektachrome and Kodachrome generally need some filtration to achieve a neutral color balance. I usually add an .025 or .05 yellow color-compensating (CC) filter if the film is a little blue, or an .025 or .05 magenta CC filter if the film is a little green. I tend to avoid film emulsions that require adjustments with a cool filter, such as a cyan, blue, or green filter. This is somewhat of a personal quirk. I feel that if the film itself is just a little too warm, that's okay. But in photographing people, if the processed film is just a little cool, it looks horrible. I feel more comfortable shooting with a filter pack consisting of an 81-series filter and either a yellow or magenta filter. I try to avoid filter packs of more than two filters because three seem a bit much and are also the limit that Kodak recommends. Beyond the three-filter limit a problem with sharpness develops.

KEEPING COOL UNDER PRESSURE

I have to be prepared if a piece of equipment I need for a shot breaks down during the shoot. Once, while on a shoot for Wrangler jeans in the middle of an open field in Ohio, I was shooting five professional tractor pullers in front of a giant tractor. They were there for a tractor pull meet and were doing the ad in the morning before the meet. They would not be available as a group again until the next meet. And, of course, this was the last meet of the season.

The morning started for me, my assistant, and my stylist at 4 AM. Joining us later were the art director, the writer, the five champion tractor pullers, and their loved ones, all waiting for the sun to get into position. When that great moment of light arrived and we were ready to shoot, the lens on my Hasselblad jammed. They will do that when it is extremely hot (which it was), extremely cold, or at the worst possible moment (which it also was).

At that point, I took off the lens and told my assistant to bring me the back-up lens. With that many people standing around in a hot, open field, it was no time to stop and try to figure out what was wrong with my lens. I continued shooting without missing a beat.

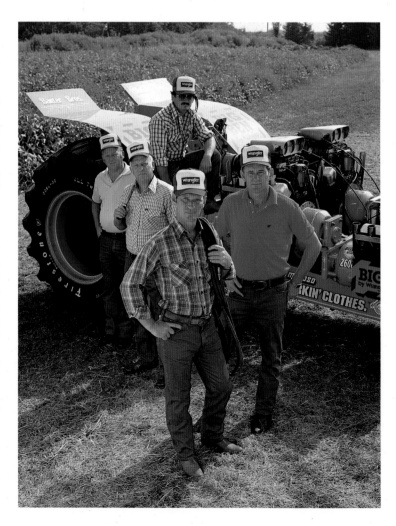

SEIZING AN OPPORTUNITY

On another Wrangler shoot at a rodeo in San José, California, I had to get a photo of a clown bullfighter that would be suitable for a poster. I took a lot of ground-level shots that looked great, but I kept looking for a different angle. When I realized that the rodeo was being put on by the local fire department, I hunted down one of the organizers and requested a cherry picker so that I could shoot from overhead. The art director ended up using a ground-level shot, but by quickly improvising I was at least able to give the client some film from a different angle.

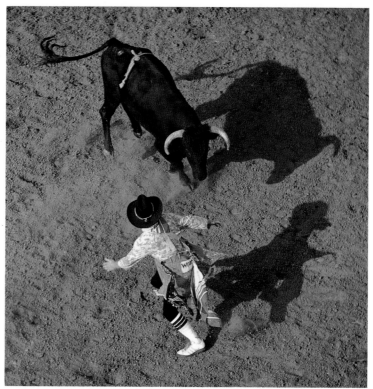

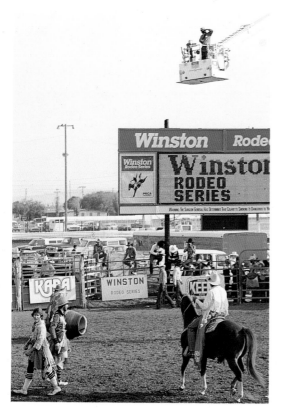

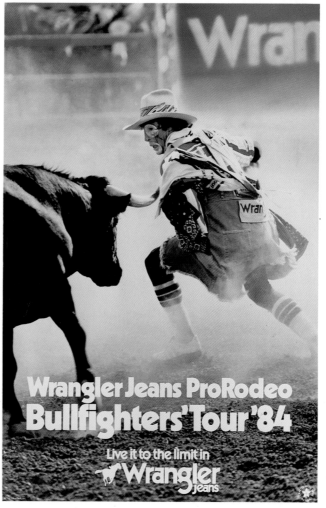

When I'm photographing people, I don't always want to achieve a neutral color balance. I have to decide what mood or feeling I'm looking for in the photograph. Sometimes excess filtration gives me the look I want; for instance, I may use extra warming filters to create an early morning look, or additional blue filtration to create a night-time look during the day.

DIFFUSION AND FOG FILTERS

In my illustration photography, diffusion and fog filters are extremely important. The extreme sharpness achieved in today's computer-designed lenses can be more of a hindrance than a help in creating photo illustrations. Extreme sharpness is not what I'm striving for, but then neither is soft focus. If some pictures are too sharp, they tend to have a harsh look to me. If they are too soft, they look mushy and out of focus. Most of the time, I'm looking for something in between. Over the years I've tried many different types of diffusion and softening techniques and filters. My conclusion is that diffusion filters from different manufacturers will give different results. Some filters, such as the Hasselblad diffusion series, create a burst of light in the highlights. A company called Harrison and Harrison makes both a diffusion series that will soften an image and still keep the edges sharp, and a fog series, graduated from a ¼-fog to a 5-fog filter, that gives an overall softness. Black stockings over a lens have also worked well for me as a diffusion material, as have white stockings, which give me more of a pastel diffusion.

It comes down to trying and testing as much as possible and being aware of what filtration will give you what effect. One manufacturer's diffusion filter is another's fog filter. Some changes are subtle, some are extreme, and some filters will change the color balance. It's not fun to see film come back from the lab with a slight green shift caused by the diffusion. I know from experience that the look of diffusion I get on a Polaroid is not the same as the look I get on film. Why this happens is beyond me. For this reason photographers *must* test their film and

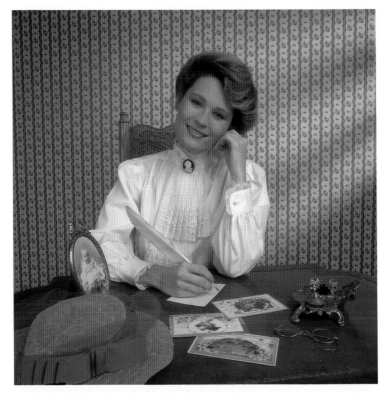

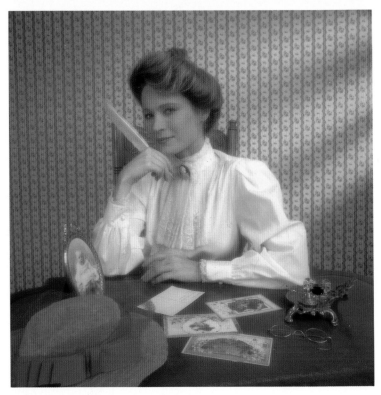

I used an 81B-series and a .10CC yellow filter to give these pictures an old-fashioned, faded appearance. To soften the bottom picture, I added a diffusion filter.

filters. For those who are hard of reading, I will repeat. Test your film and diffusion filters, because what you see (on Polaroid) is not what you get.

THE LAB DID *WHAT* TO MY FILM?

I never send my exposed film from a shooting session off to the lab at one time. If anything happens, a power failure, a malfunction in the processing machine, for example, my entire job is shot, so to speak. I always hold back some of the film, and I don't process it until after I have some of the processed film in my hand. My clients seem to understand a slight delay in receiving the film if I explain to them what I am doing.

In my system of shooting, I mark one film back with white tape and keep it on the set as the "test" back. Whenever I start any shoot or make any changes while shooting, I shoot a test frame. At the end of the shoot, the test roll is sent to the lab first. When it comes back processed, I have a visual reference to the entire shoot. I then compare it with the film notes carefully kept by my assistant. (Messing up my film notes is a sure and quick way for an assistant to get fired.) As I shoot, my assistant keeps notes on which frame of the test roll corresponds with which roll of film.

In volatile situations on location, I shoot one test frame before each roll. That way, frame #1 on my test roll corresponds to roll #1, test frame #2 corresponds to roll #2, and so on. In the studio where there are fewer variables, I don't shoot as many test frames; frame #1 may correspond to rolls #1 to 4, frame #2 to rolls #5 to 7, and so on. I shoot tests whenever a light is slightly moved, when a model changes wardrobe, when a prop is changed, or when there is any change at all. I also shoot one every four or five rolls, just to be safe.

After studying my test roll and the film notes, I will then send to the lab half or less of the film I have shot. When I have that processed film in hand, I will send off the rest of my film.

With 35mm film I do the same with a test body. When I shoot Kodachrome I don't have a test, but the film is sent to Kodak in two batches. If the client is in a rush and can't wait for two Kodak runs, some of the film is still held back. (I decide which rolls to hold by looking at my film notes. I also shoot with the knowledge that enough film has to be shot on each situation to hold back film.)

A lot of photographers use clips instead of test rolls and notes. The lab cuts, or clips, a piece of film from a roll, usually one or two frames, and processes it. In clipping a film, one frame is always lost because the lab has no way of knowing exactly where the frames are. I don't like to have my film clipped because the frame that is cut into is, more often than not, the one where the model has the best expression or all the models are finally doing what they are supposed to be doing.

On one job, I sent off the test roll to the lab, and when the film came back and looked great, I sent the first half of the film I had shot back to the lab. After this batch was developed and returned to my studio, I discovered the film was green. I don't mean not ripe, I mean GREEN. There had been a water problem at the lab. The shot, of course, was not against a white seamless backdrop; the scene was a two-room set, complete with ceiling. And of course the set had already been dismantled after I had seen the test roll. Because of other shots I had to do that day, and because of the expense of prop rentals, almost everything had been taken down or returned. I rarely take down a set before the film is in the art director's hands and approved, but of course this was the one time I had decided not to wait.

I had the lab run a clip test from the second batch that I was saving, and it came back almost perfect, just a little too blue. I had the lab add a little yellow in its processing, which is done by adding a minute amount of acid to the developer and changing the pH. Changing the pH enables a photographer to control the change in color.

The next clip test the lab ran looked perfect, and I was able to send in the second half of my film. It came back looking great. I had each situation shot covered by the second batch of film, which I had held back.

Jack Reznicki Studio Inc.
Data Sheet

Job #: **675** Client: **R.D.** Product: **MOOD MUSIC**

Date: **4-9-87** Film Type: **EPN 120 Em #098** Pol. Total: **29** Asst: **ROBERT**

Roll	Test Roll	1st Run	2nd Run	Exp.	Description and Changes
1	T(1-2)			16½	
2					
3					Δ'd WARDROBE
4					ADDED TREE BRANCH
5	T.(3)				
6					
7	T.(4-5)			16½	
8					
9					Δ'd UMBRELLAS, MAN /w MULTI-COLORED
10					
11	T.(6)			22	↓ ½ STOP
12					
13	T.(7-8)			16½	
14					PUT ON RED SWEATER
15					
16					
17	T.(9)				W/O MISTLETOE
18	T.(10-11)			16	
19					WOMAN POINTING
20					
21	T.(12)				
22					WOMAN POINTING
23					
24					
25					

A WARNING

Getting lost in the technical aspects of photography is dangerous. Although it is extremely important to have a strong technical background in order to understand your craft, it is just as important to have an understanding of what you are trying to produce. To me a great photograph—especially of people—is an expression of emotion, not a technical execution. The combination of the two is ideal, but if I had to do without one, I would be more willing to lose the technical than the emotional aspect.

When people look at my photographs, for the most part, I like to see an emotional reaction—a smirk, a grin, a laugh, a groan of recognition, a wistful smile, or even a simple "Wow." A stone-faced look and a "nice shot" reaction are very depressing and disheartening to me. Of course I am talking about the shots I become attached to. When I show a generic shot of a family of four (mom, dad, boy and girl) reading a book together on a set that consists of a couch and a roll of seamless paper, if the art director or client looks stone-faced and says "Nice shot," I am very happy. It means I have succeeded in not making it look too stiff and posed.

Keeping a complete set of exposure and processing data for every roll of film I shoot enables me to pinpoint exactly how I want to process the final image.

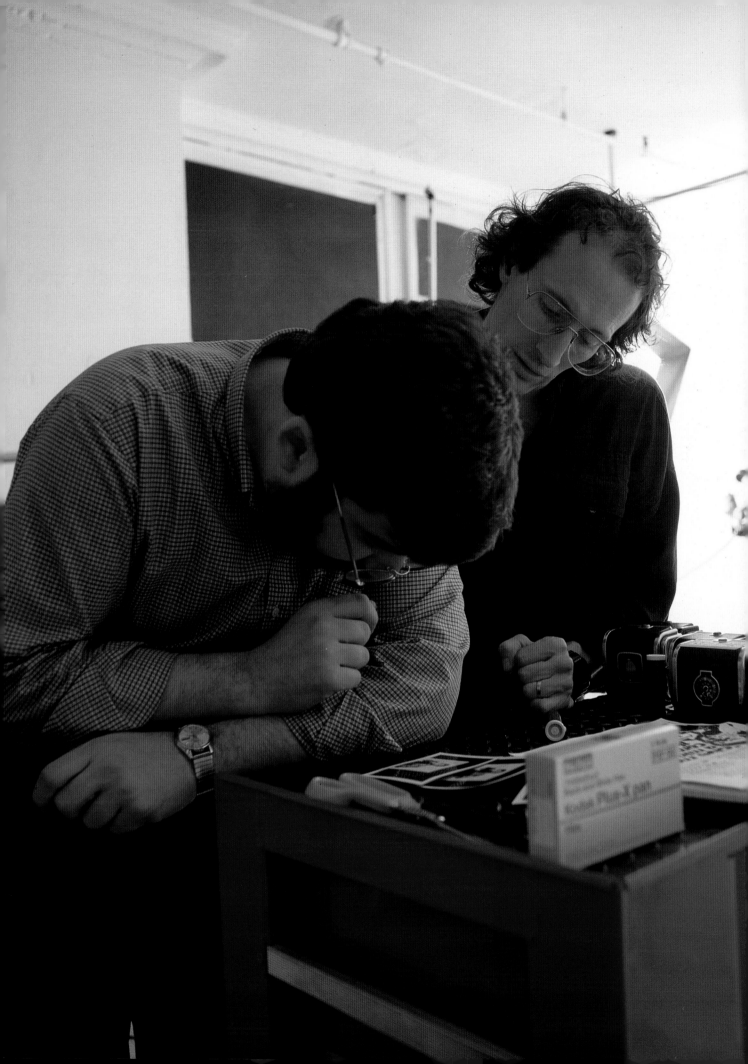

ASSISTANTS, MODEL MAKERS, AND STYLISTS

No man is an island and no illustration photographer is a hermit. I didn't create the photos in this book by standing behind the camera by myself and commanding my models to "say cheese." Illustration photography is very much a team effort; it would be impossible to do alone. My concentration and timing would be shot if I had to stop every five minutes to load my camera and keep my film notes. I usually have only a few days between getting an assignment and doing the shot. In this short time all the preproduction work has to be done: models have to be cast; props need to be found; locations must be scouted; sets have to be built, painted, and wallpapered; a wardrobe that fits the models chosen has to be assembled; and so on, and so on. With more than one job in house, a staff is essential.

The people on my staff and the freelance people I hire are not simply drones performing a task. They are all very talented and always seem to bring an individual boost to whatever they work on. My assistant or my stylist might have a great idea that not only improves the shot and enables me to see things that I might have neglected, but also expands my awareness of the possibilities. Sometimes I get so wrapped up in what I am shooting that any suggestion, good or bad, makes me stop and see what I am doing from a different perspective. The best support people know not only when to make suggestions but also when not to make any. The worst either make no suggestions— they never think, they just do—or they are the type of people that never stop suggesting things all the time, simply for the sake of hearing themselves outloud.

ASSISTANTS

Photography assistants are extremely important in the completion of any job, be they full-time people on staff or freelance people hired for the job. My freelancers tend to be people I hire often, so they know my system of shooting and my quirks. If I hire someone freelance for the first time, odds are it will be as a second or third assistant so he or she can learn from my first assistant the way my studio works.

Most of my assistants are aspiring photographers, assisting so they can learn. Assisting is basically serving an apprenticeship. It is hard to make a career of being an assistant. The hours are very long (ten to sixteen hours a day is common) and the pay is low, but the education an assistant gets is priceless. There is no better education in photography than learning by being a photographer's assistant.

Although I received my BFA in photography from Rochester Institute of Technology (RIT), the truth is that I learned more about photography in one year of assisting than I did in four years of college. If I had it to do over again, I would do it exactly the same way the second time around. RIT has an excellent program, probably the best in the country, and when I went to look for work as an assistant in New York, my degree

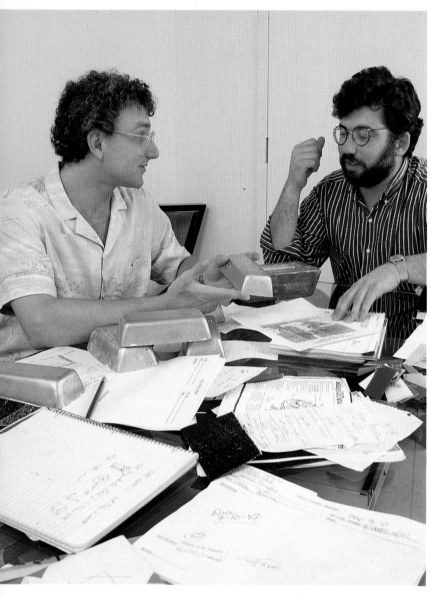

Here I am with master model-maker Mark Yurkiw, going over the plaster gold bricks for the alchemist shot on page 89. Oh, if he could only turn them into real gold bricks.

photographers whose work I had studied in college. How did I get to assist these people? Mostly by being a good assistant and letting my reputation spread by word of mouth. Most photographers in New York like to hire assistants by recommendation. Even for a second or third assistant I don't want to hire a person who turns out to be either a "lemon" or a "couch potato." I want to hire people who know what they are doing and can think. When I am looking for an assistant I usually call other photographers—people who were assistants with me in the old days, photographers whom I myself assisted and with whom I still have a relationship, and assistants I have used.

There are advantages to being a freelance assistant and also to being a full-time assistant. Working full time affords the opportunity to see a job from start to finish, warts and all; the assistant learns how a shot is produced and what paper work is involved. Full-time assistants also learn the day-to-day operations of a studio, including such things as how to paint a studio or maybe build shelves when times are slow. After leaving a full-time position with a photographer, an assistant is likely to be hired freelance by that photographer.

A freelance assistant who works for a variety of photographers who, for example, specialize in still life, fashion, personalities, location, editorial work, or corporate work, has a chance to learn from these specialists. Within these areas there are further specialists. For example, in still life there are food specialists, special-effects photographers, graphics specialists, room-set specialists, and so on. In fashion, there are specialists in children's fashion, men's fashion, women's fashion, and high fashion. The variety is rich and exciting.

Assistants seem to come from a variety of backgrounds and to be of many different ages. One well-known director of TV commercials started out when he was a high school dropout as an assistant to a photographer of babies. Another well-known photographer started out assisting at age forty. Several assistants I know are refugees from the medical profession. One gave up being a pediatrician to learn photography. One of my assistants was

turned out to be one of the best recommendations I could have. In fact, the photographer I first worked for in New York full-time had been an RIT graduate sixteen years earlier.

Those first six months assisting were a real eye-opener. The pace of putting together a professional shot was light years away from the pace in college. Each shot had to be on the bull's-eye each time. Every time a professional photographer takes a photograph, his or her reputation is on the line. Watching a professional shoot national ads every week and hit the target each time was quite an experience for me. There were never any excuses, just results.

When I started working as a freelance assistant, it was very heady to be hired by

previously teaching pulmonary diseases to medical students.

What makes a good assistant? A knowledge of photography is extremely important but not necessarily the only requirement. The technical part of photography can be learned quite quickly, although it does take a lifetime to master. I don't know any really good photographer who is not learning or trying something new all the time. Finding an assistant who is a technical whiz is easy; schools are turning them out all the time. What I am looking for is someone with a lot of common sense, someone who can see the entire forest, not just the individual trees. Because of the dynamics of the job I do, a person who gets completely wrapped up in an individual task without keeping his or her eyes open and mind in gear is useless.

I also look for people who are good at improvising and can think on their feet. An assistant who does only what he or she is told and nothing more is not a good assistant. For example, I was once on a location with a gasoline generator when I discovered that someone forgot to pack power cords for the strobe units. The assistant cut apart an extension cord with his Swiss Army knife (an assistant's most important tool) and hot-wired the strobes. No fuss was made. It was done quietly, quickly, and without the client's knowledge.

The responsibilities of an assistant are basically to make sure the photographer has a loaded camera or a loaded Polaroid camera back, to keep film notes, to make sure all strobes are firing, and to keep an eye out to make sure everything on set and during the shoot is running smoothly. It sounds easy enough until it has to be done at break-neck speed and under impossible conditions—a rainy or overly cramped location, or a two-hour job that has to be shot in one hour. When the photographer is working with models who are getting paid $250 per hour and six of them are on the set with their meters running, an assistant shouldn't be shooting the breeze; being on the set is a time for professionalism.

A good assistant also has to be discreet. On set a bad assistant will loudly announce when he or she sees something going wrong, such as a strobe not firing or a prop out of place. A good assistant will quietly whisper into the photographer's ear at an appropriate time. As an assistant myself, many times I would quietly mention something to the photographer. Sometimes he or she was already aware of it and wanted it that way. If the suggestion turns out to be a good idea, the photographer will take credit for it, which is the way it should be. The photographer is the one who is supposed to look good and be in control. The assistant is there to assist. There are no brownie points in making the assistant look better than the photographer. As an assistant, there were times when I would be blamed for something on set that was not my fault. I would still take the blame and straighten it out with the photographer later, after the client had left.

It's amazing, but some assistants have been around for years and still don't have the hang of assisting, while others understand the dynamics of assisting the first time they are on a set. Good, hard-working assistants for the most part go on to be good, hard-working photographers.

MODEL MAKERS

Model makers have a really fun role as part of the creative team. Labelling them "model makers" may oversimplify what these people actually do. They are really problem solvers who can produce or create almost anything, such as incredibly oversized or undersized props and fabrications, and such special effects as rain, fire, and exploding props. Almost anything a photographer can think of, model makers can build or solve. They are the troubleshooters of the photography field. When I go to one with a problem, he or she either helps me come up with a solution or builds me a great toy to photograph.

The model maker I use most often is Mark Yurkiw. Mark will either solve my problem or tell me who to contact, even if it's another model maker. (The wheat field growing in the kitchen, shown on page 119, was created by Richard Townsend, a model maker recommended to me by Mark Yurkiw. Mark couldn't do the job because of scheduling problems.)

Mark made the gold bricks and the solid pour shown on page 89. He has also done rain effects, riggings, and a frozen drip of water in a faucet.

There are many model makers around who make models and prototypes for industrial needs. Model makers who work with photographers are different—they create according to the camera's specifications and demands. Most of the time "good enough" is not good enough when it comes to the unblinking eye of the camera, which requires perfect color as well as perfect form. Props made by a model maker can be fairly expensive due to the exacting nature of the work and the deadlines involved.

If I went to a model maker to order a 3-foot ant, I would be bombarded by a barrage of questions: "Do you mean 3-feet high or 3-feet long? What species and what color? Are there any moveable parts? Does it have a personality, such as a nerd ant or an athletic ant or a spy ant?" Now, no matter what price a good model maker quotes me, I know I can always find someone to build it cheaper, maybe at as little as half the price. But the cheaper version is usually with someone who is not familiar with working with photographers. A cheaper version usually means a cheaper looking version. Personally, I am not willing to take that kind of a chance with a client's time or budget. This is not to say that I won't shop around for estimates to see if I can save a client some money, but I will not compromise on quality for price. If I shop around, I do it with model makers who I know work with photographers.

Model makers charge according to what needs to be done and how fast. Deadlines are a big part of the advertising world, and when a model maker commits to a deadline, he or she knows there are no excuses, no "ifs, and, or buts." The model has to be perfect and on time. But the faster a photographer wants something, the more it's going to cost.

I once had to photograph a family of four at a picnic table for a "how-to" book. I took the plans to Mark, who, if I remember correctly, quoted me $1,200 to build the table and benches, including materials and lumber (redwood in this case.) The client found a woodworker who could do it for a lot less, which made sense to me. The model was to be delivered to my studio on Monday. I scheduled a Tuesday shoot. I built a large backyard set that filled most of my studio. I had a shoot with another client scheduled for Thursday.

Monday came—no table. I was told "It will come Tuesday morning." Tuesday morning—no table. The models had to be cancelled, which meant my shoot day was cancelled. Now the client was out more money in cancellation fees than the difference between the model makers' prices. But it got worse. I still had to shoot on Thursday, and by Wednesday I still hadn't heard from the woodworker. It was too costly to tear down the set and rebuild it, so I rented another photographer's studio on my floor, and billed that as a rental fee to the client who was tying up my studio space with his backyard set.

At this point, with the client's deadline looming like the sword of Damocles over his head, the woodworker just disappeared. On Friday morning I gave Mark the go ahead to build the table and benches. His price to have it ready on Monday?—$2,500. Monday morning Mark delivered a beautiful redwood table and matching benches. We did the shot Monday afternoon.

Normally, because such props are the creations of the model maker all props remain the property of the model maker unless other arrangements are negotiated. But Mark was very reasonable. He let me keep the table because he didn't have the storage space in his workroom for it and because he knew I didn't want to explain to my client why he didn't own this $2,500 picnic table. (Somewhere on the East Coast during a summer's eve, people are eating hamburgers and hot dogs at a very expensive redwood picnic table.)

Model makers are not just for building models. I've called on Mark many times for help on going over how to approach a job. If he thinks its easier done without his help, he tells me, and then he tells me how to go about solving whatever problem is at hand. Some rigging problems I do myself, but on complicated riggings, if I foresee problems, I call on Mark and his elves. The same is true for creating rain

effects. If the shoot is outdoors, I'll do it myself. But if it's indoors, I call Mark who sends me his rain specialist, Mark McAniff. He orchestrated the rain effect in "Changing the Weather Indoors" on page 104. Like all other model makers, he asks all sorts of questions. "You want rain? Okay, what kind? A summer drizzle or a torrential downpour?"

STYLISTS

Finding a good stylist to "dress" the set with the right props and dress the models in the right clothes can be a lifesaver. On many shoots, the stylist is my closest associate besides the client's art director.

My first contact with the stylist is usually over the phone to find out if he or she is available for the dates I need. I tend to call stylists according to how often they've worked with me and how well they know my tastes. I also hire them because of their particular area in styling, such as clothes, period props, and so on. The stylist I use most often is Cathy Lake, who had originally worked with me on staff and who is very familiar with my methods and aims.

We have several discussions before she starts working. A good stylist asks many questions, makes several suggestions, and begins by thinking about the nuts and bolts of a job. A stylist needs to get as much information as possible.

The most powerful tool in a stylist's bag of tricks is knowing where to get the commonplace—the right nightgown for a hen-pecking, curler-clad wife, for instance. It can't be the type of nightgown one buys at Bloomingdale's or Saks Fifth Avenue but a more down-scale, K-Mart-type of nightgown. Many times an item that I've seen a million times may be a lot harder to find on demand than I think. The right prop, such as a wall clock in the shape of a cat with the clock in its stomach, can set the tone for the entire shot.

And then there is the stylist's nightmare—a last-minute job three days before Christmas. The props are all simple enough to get, but they are all at Bloomingdale's. Being able to find props at Bloomingdale's three days before Christmas separates the professional stylists from the amateurs.

Many people look at stylists as professional shoppers. But I see them as professional bloodhounds searching out the perfect prop and bringing it back to the studio on time and on budget. They can make me as a photographer look very good, but on the other hand they can also torpedo a shot. The wrong prop or not being able to locate a prop can make me look very bad.

Sometimes when an art director wants something changed, I turn to my stylist and say, "Run out and get a ＿＿ and be back in a half hour." The look I receive is one of shock and panic. Panic disappears when replaced with experience. Whenever I work with a seasoned stylist, I get a comforting look of experienced shock.

This is my stylist, Cathy Lake, acting as a baby wrangler, or someone who keeps the baby's attention.

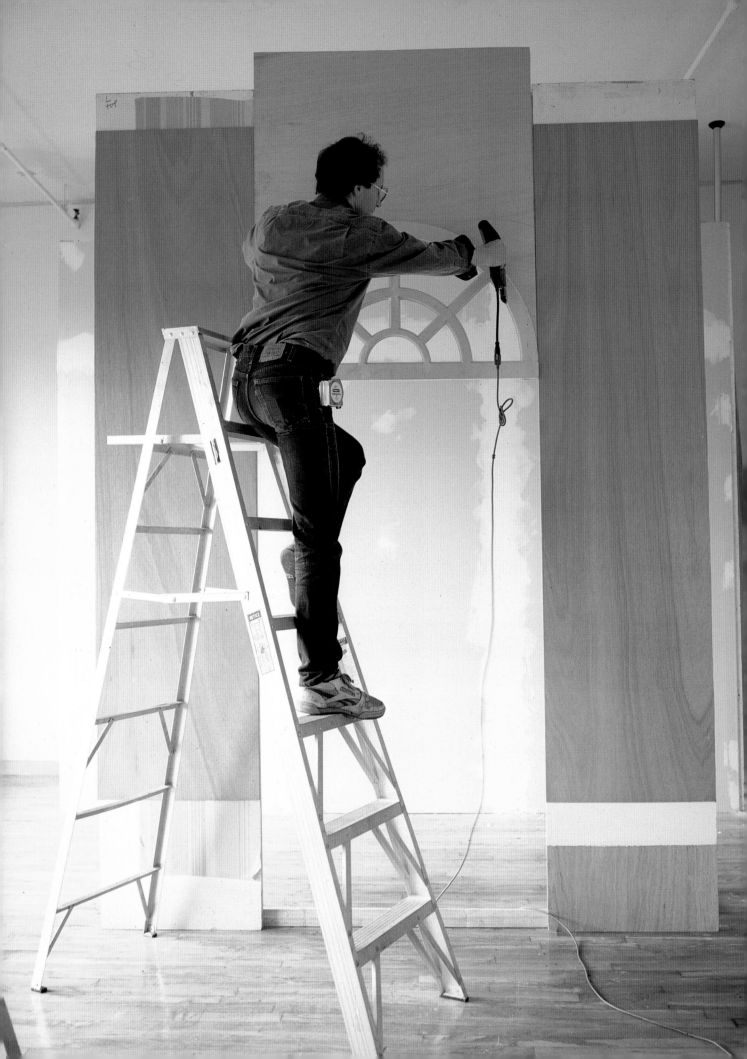

BUILDING A SET

There are three steps involved in planning and building a photographic set. First, I have to decipher the art director's layout and make sure that the agency's expectations are within my budget for the shoot. If not, we may have to make some compromises. Then I visualize how the set will look in my studio, and I work out details of proportion and how space will be allotted for the set's various elements. Finally, my crew and I construct the set.

It is important to overbuild the set slightly or, in other words, build more set than is apparently needed. I've found that I often need a little extra space to try a different angle, a wider lens, a last-minute idea from the art director, or simply because putting models in the set gives it different proportions or a different physical look from what I expected. Perhaps the assistant who was stand-in for the model was 5 feet 8 inches tall and thin and the model turns out to be 6 feet 2 inches tall and heavy. The model may not fit in the frame the same way as the stand-in.

I keep a camera on the set during its construction so that everything being built looks correct through the viewfinder, and I make sure there is a garbage bag over the camera at all times except when I'm looking through it. Building a set raises a lot of dust in a studio—I'm talking about enough dust to fill a garbage bag. During construction, all the cameras, strobes, and any other equipment susceptible to damage from dust should be put safely away. All my strobe equipment goes into cabinets and my camera equipment is put into cases that go into a safe. In my previous studio I did not have enough cabinet space, so all my equipment went into location cases.

AT THE DRAWING BOARD

One of the first things I have to determine is how high and how wide I want the walls and where I want them. The height is determined by looking at the layout. Most set walls, or "flats" as we call them, are either 8 feet or 10 feet (2.4 or 3 m) tall. The farther away from the wall I shoot, the more wall I need. The closer to a wall a model is placed, the greater the chances of his or her casting a shadow from a front light on that wall and the less depth I can get in that shot.

For complex sets of multiple walls or multiple rooms, I also erect walls of 4 × 8-foot (1.2 × 2.4 m) foamcore supported by stands or by auto poles, also known as "pole cats." Auto poles have adjustable spring action so that they can be tightened between two solid surfaces such as a floor and a ceiling. This helps me rough out complex sets and enables me to see how high or how wide a wall should be. If an 8-foot (2.4 m) tall foamcore wall does not give me enough coverage, I know I'll need a 10- or 12-foot (3 m or 3.7 m) wall. I do not prebuild the set with foamcore; instead, I rough it out, sort of like a visual doodle. When looking through a camera, it's a lot easier to visualize a set using pieces of foamcore, rather than just tape marks on the floor.

THE NUTS AND BOLTS OF SET CONSTRUCTION

The illusory world of a photographic set is in reality composed of building blocks called "flats." A flat is a wood frame covered with a piece of plywood. It should be as light and as sturdy as possible. A flat made out of 2 × 4s (5 × 10 cm) and a ¾-inch (1.9 cm) plywood would be ex-

tremely heavy, unwieldy to maneuver, and too bulky to store. The flats I have were made by a television-union carpenter. They were expensive to make originally but have lasted for more than two years now. To create a window or a door, a small flat is needed above and below the window or above a door. This type of flat is called a "plug" and is built the same way larger flats are built.

If I do not have enough flats, I have to rent more or build more. Building them, because of the cost of labor, materials, and, in New York, transporting material, can be very expensive. The flats I have are built with 3/4-inch (1.9 cm) clear pine and are covered with 1/4-inch (0.6 cm) plywood finished on one side, known as "luan." Luan can be found in almost any lumber yard. This gives me a very light, sturdy flat that can be stored easily and takes up a minimum of space.

To put up several flats to make a wall, I will first lay the flats face down on the floor, butt them together, and then screw them together. I use Sheetrock screws and a hand drill with a Phillips head attachment. This method is very quick for assembling flats and taking them apart. It is important to remember that whatever I build has to be taken apart and, in the case of flats, used over again. After the sides are screwed together, I run 1×3-inch (2.5×7.6 cm) lengths of wood across the backs of the flats to keep them rigid.

When all the flats are attached to one another, two or three of us will lift what will be the top of the wall and walk the flats upright. I can then support the walls either with jacks (diagonal pieces of wood), timber toppers (a spring-loaded box that fits on a 2×4 (5×10 cm) so that a length of wall can be secured between floor and ceiling), or auto poles.

Jacks seem to provide the sturdiest support. I put a jack on both ends of each wall and every 4 feet (1.2 m) behind the wall. The bottom of the wall is nailed or screwed into the floor, and the jacks are nailed or screwed into flats. Before the jacks are nailed to the floor, a level is placed on the wall to make sure it is level. I then nail the jacks to the floor, which means that I have a lot of small holes in my floor. I find nailing a flat in this man-

ner is the sturdiest way to secure a wall. If I cannot nail into the floor, I can get away with lots of sandbags placed on the bottom of the jacks. If I use timber toppers, auto poles, or pole cats, I have to use C-clamps to secure them to the flats, and these methods of support are not as secure as using jacks.

Once the wall is up, secured, and leveled, it has to be covered with something in order to protect the expensive flats. If seams in the wall are not important because of texturing or great distance from the camera, I can add another piece of luan, finished side out. If I am going to wallpaper or paint, I may want to cover the flats with 1/4-inch (0.6 cm) Sheetrock instead of luan and tape and spackle the seams. The local lumber yard is a good place to learn more about taping and spackling, a subject that is also well covered in books on home improvements. (After building a few sets, most photographers feel as if they could build a house.)

Sheetrocking, taping, and spackling create the most perfect walls but this is also the most time-consuming method in that it involves two or three coats of spackle and the time for the spackle to dry and be sanded. An alternative is to hide flaws with molding, (molding is one of humanity's better inventions) which can also add some nice detail to the set. Indeed, molding is often added to a set not to hide imperfections but to give a room more ambience and texture. It is amazing what molding added to a wall, door, or door frame can do to improve the look of a set. In my case, it not only visually improves the set, it also saves me a lot of time.

Another way to create a wall and avoid the mess of sanding is to use muslin. After assembling the flats on the floor, I flip the flats over onto blocks or apple boxes so that the flats face the ceiling. I then stretch the muslin over the flats and fasten it to them with a staple gun, much the same way I would stretch canvas over a frame. The wall is put up in the normal fashion and can then be painted or wallpapered.

If I am going to paper the wall, I must size the muslin while it is on the flats. Untreated muslin is very absorbent and will cause the wallpaper to shrink an ex-

cessive amount, which will also cause it to come off the wall as it's drying. If there is no sizing available, painting the muslin will also size it sufficiently. Muslin is fairly inexpensive, about $4 to $6 a yard in 104-inch (2.64 m) widths. Besides raising a lot less dust than Sheetrock, using muslin also makes it a lot easier to tear the walls down and throw them away. Trash men may ask for extra money to remove five or six sheets of Sheetrock, but muslin can be quickly torn down, balled up, and placed in garbage bags for routine disposal.

AN ARCHED DOORWAY

Although the layout for this assignment required a very simple set, it included a backlit arch over a doorway, and both had to be constructed in the studio. The first background shot shows my assistant, Bruce Wodder, attaching flats to an overhead plug that contains the arch. He is measuring the width of the doorway to make sure the doorway is even all the way down before he attaches the brace at the bottom of the door. The wall behind him is already up and spackled in preparation for being painted.

In the second shot he is attaching luan plywood to the flats with the aid of a brad gun. Using a brad gun rather than a hammer cuts down the time spent nailing tremendously. In the third shot he is done spackling and wallpapering and is painting the trim.

The two final pictures made for the client show some of the different variations I shot during the one-hour booking. If possible, I always try to give the art director a good selection of pictures from the shoot.

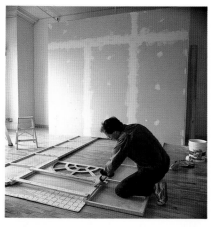 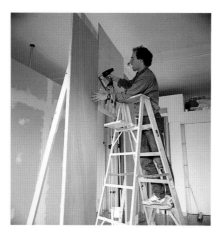 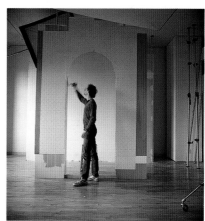

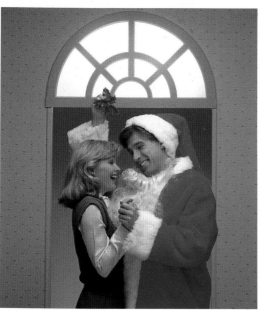 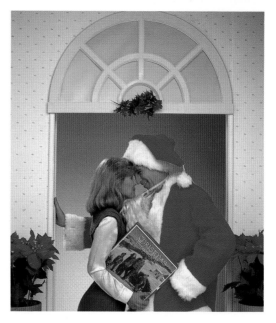

WORLD WAR II NOSTALGIA

This shot was done to advertise VHS tapes of Frank Capra's "Why We Fight" movie series, which he produced during World War II. The photo must have worked since art director George Corbellini told me months later that they sold lots of tapes.

When I first received this layout and did the estimate, the estimate was too high for what the client, Reader's Digest, had to spend. I had to cut the estimate down. I really liked the layout and concept and didn't want to lower the production quality, so I lowered my fee. Reader's Digest is a steady client that gives me lots of work, so I was more willing to compromise on my fee, knowing that it would be made up in the long run with other assignments.

The only item of the layout that I did cut out was the window in the back room. Including a window is very expensive because there has to be something to see outside the window. A painted backdrop with a few fake branches and shrubs would have been very costly and would still have looked fake. Instead of a window, the art director and I decided to show a fireplace. Ultimately, for this shot I needed a set designer to lay out the set, coordinate the colors, provide props, and supervise the set builders; a stylist to assemble the wardrobe; and a makeup person to dress hair and apply makeup.

I also put in a wall with a curved opening between the front door and the living room. I didn't want the front door to open into the living room directly. It was also at this point that the little girl was added. I thought it would be cute to have the sister peering shyly around the corner.

A budget of $7,500 was approved for the set, the props, set designer, set builder, clothes stylist, and makeup artist. Fees for the models and me would be separate.

This layout is typical of the fifth-generation black-and-white photocopy that advertising agencies give photographers.

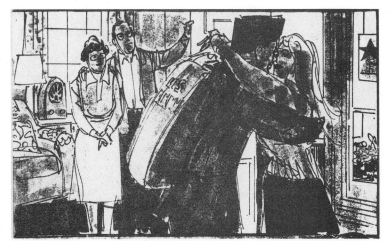

It took two days to build the set. Several days beforehand the set builder met with the set designer and determined what he would need in the way of lumber, molding, paint and other supplies. He ordered them and made sure they were there ready for him and his assistant when they came to start building. The first attempt to build the curved opening did not have the correct visual effect. After looking at it through the camera, I had the set builder tear the curve down and rebuild it. It is very important not to be afraid to redo something at this stage of the project. I have found out that something that bothers me a little now will later bother me a lot. And in the final photograph, my eye will zero in on that flaw. No one else may notice it, but it will always bug me.

For this shot I wanted to be able to place the back models a good distance from the back wall, which meant that the wall had to be fairly tall. This extra space gave me enough room to place a back light behind them, giving an edge of light. An alternative to a tall wall would be to have a ceiling. That, however, would create problems because I could not use lights from above, not to mention the additional cost. In some cases, a ceiling looks great and really finishes the room. Sometimes the camera's perspective requires a ceiling. But in this shot, I did not feel it was appropriate. Here, 10-foot (3 m) flats were correct.

Unfortunately, the set designer did not talk to me about the back wall and specified 8-foot (2.4 m) flats to the set builder. After the set was built I could see that the back wall was too short. My assistant and I added a 2-foot (0.6 m) vertical flat called a header on the top of the back wall. Since it was added after the wall was up and painted, it did not have a perfect seam and we did not have the time to spackle it and smooth out the seam. We covered the seam with a piece of molding and painted and wallpapered the header.

It took two full days of building and correcting the work to get to this point. Then it took another full day to dress the set. By "dressing" I mean putting the furniture, accessories, and props in place. The props had arrived while the set was going up. It was during this prep day that I pre-lighted the set and tested the film for the different filtrations I might use. By the morning of the shoot, I knew which filters I would be using for color and which filters for diffusion. If the art director had disagreed with what I picked, I had the tests to show him which different directions we could go in in terms of color or softness.

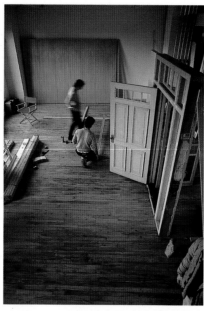

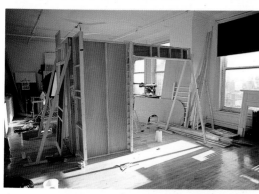
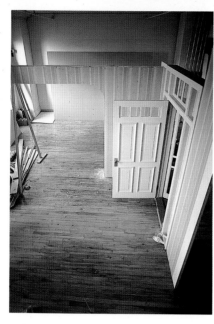
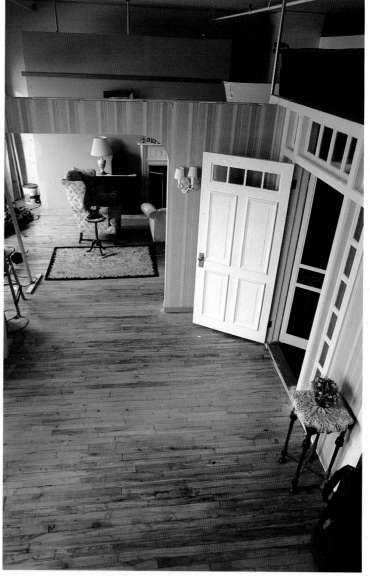

I usually will shoot a job like this in the afternoon so that I can have the morning for any last-minute adjustments. The models were booked at staggered times. The girl friend was first as she needed the most time for makeup; she was followed by the mom and by the soldier, who needed to have his hair cut. The little girl's hair was done by her mom, and the model who played dad arrived last. The shooting time was an hour and a half plus the time for makeup.

The models did not charge me for the extra time we spent after the "official booking" in order to take extra shots for their portfolios and mine.

When the shot was over, the film processed and edited, and the job delivered and approved, there was still one more day's work in packing and labeling the props and striking the set.

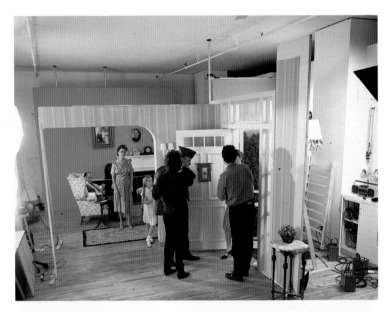

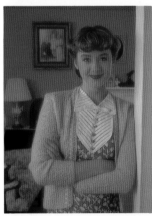

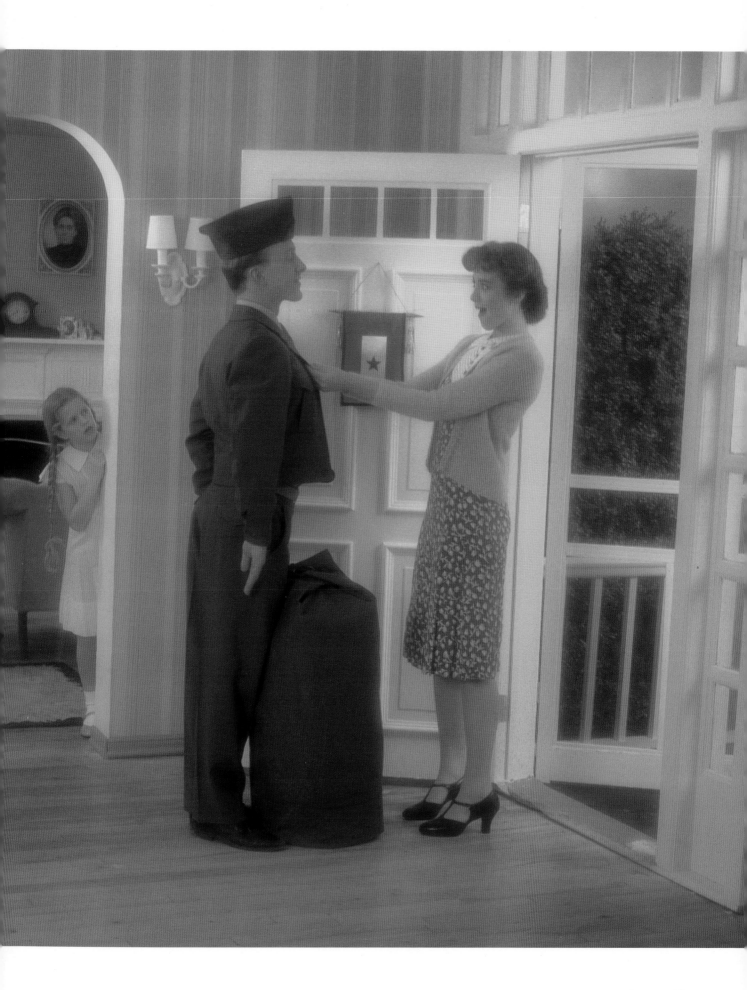

BACKDROPS

So what do I do when I need a beautiful outdoor background and it's February in New York? And the art director says he needs the shot yesterday? And I have a small budget? Well, unless the agency is willing to fly me to the Caribbean, I rent a painted backdrop.

There are four or five backdrop sources in New York, and they ship backdrops all over the country. They stock all kinds of backgrounds, enabling photographers to create new scenes at the drop of a canvas. For $300 to $600 anyone can rent a preexisting backdrop—a blue sky with clouds, a sunset, a street scene outside a window, a seascape, or even the house in Grant Wood's *American Gothic*.

Photographers who have hefty budgets can commission backdrops to be painted according to their specifications. They have to pay extra if they want to keep the pieces they've commissioned. Since each backdrop is an original work of art, the copyright is owned by the painter, just as a photograph's copyright is owned by the photographer, even though someone else assigns the work and pays for materials. A photographer pays for the rights to photograph the backdrop and incorporate it into his or her photograph or ad. The way these backdrop rental places acquire their stock is by owning the rights to the canvases they are commissioned to paint. By computing if a canvas on order has an afterlife in future rentals, they determine how much to discount the price to the photographer if the backdrop company keeps the canvas.

ANOTHER HAPPY COUPLE

This "American Gothic" is a photograph of me (I'm the one with the beard) and Elyse Weissberg, my sales representative. She is holding my portfolio in her arms because she never seems to be more than 3 feet from either my portfolio or a phone. The backdrop is apparently very popular and is available at several backdrop rental services.

To duplicate the direction of the sun in the backdrop, I used a medium bank light on one side of the set, and there were also several lights aimed at the backdrop to keep it light. After I set up the shot, my good friend and neighbor, Nick Samardge, handled the camera work and directing.

I used this photo for a self-promotion piece. It became a label for "Apple Jack's Cider," a product of Reznicki Vineyards. Elyse and I put the labels on quarts of apple cider and passed them out to art directors, which was a big hit, and resulted in many photo calls to see my portfolio.

BEAUTIFUL MEMORIES

"The Most Beautiful Songs of the Century" was another direct-mail brochure project that I did for Reader's Digest. The art director, Paul Omin, wanted the background to be soft, diffused, pastel colors, and he needed the shot right away. I rented a painted autumn backdrop from Sandro La Ferla Backdrops and created a nice, colorful background very simply and easily in my studio.

I used one large bank light and a large 4 × 8-foot white card for fill. Some other lights were used to light up the background, so that it wouldn't go dark but rather stay light and airy. I determined the ratio of front light to back light by looking at the different Polaroids I took. I didn't care what the exact difference between the front light and the back light was in *f*-stops, as long as it looked the way I wanted it to on film. Odds are that the background was one-half to one stop brighter than the foreground.

For the second shot of model Barbara McKay, I just moved the front bank light to the other side and used a different part of the backdrop. It's amazing how many different looks you can get from one backdrop.

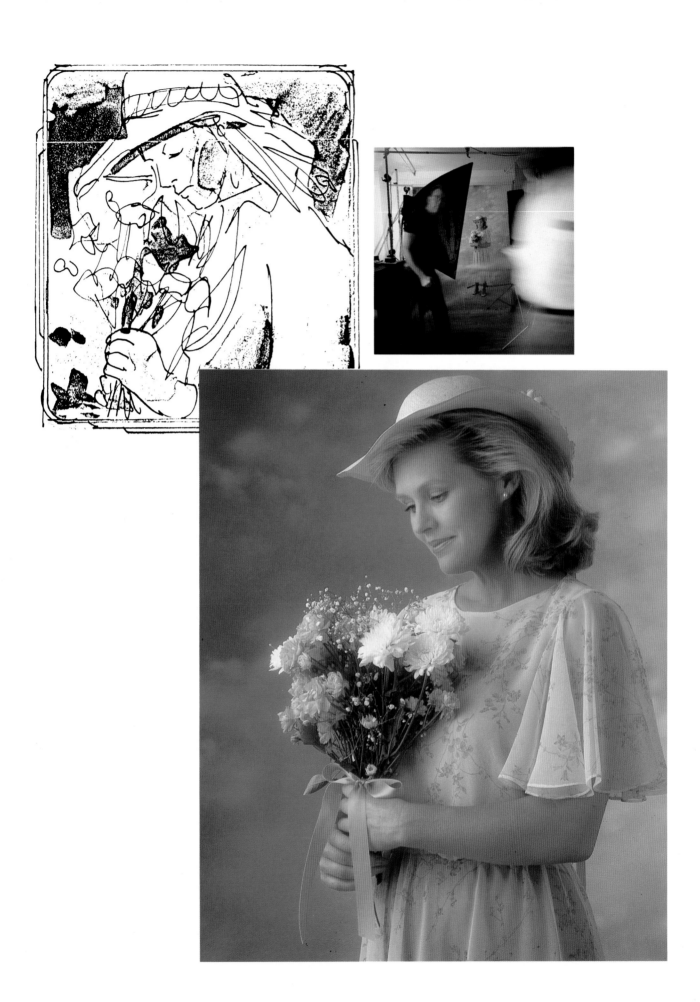

MY MOTTLED BACKDROP

The painted canvas shown in all these pictures is one that I own and painted myself over a period of several weeks. I would paint a little, then spray paint it a little, then sprinkle some dirt on it and walk on it, and anything else I could think of to give it some texture. Then I would leave it alone for a couple of days, take a new look at it, and start again with the paint. I use my painted canvas in many of my shots, and I can give it a completely different look by moving the model closer or farther from it, by using a wide-angle lens or a telephoto lens, or by putting a back-light on it. I can also change the color of the backdrop slightly, as in the photo of the black teenager holding a video camera, by adding warming filters to the camera lens. I am currently creating a new backdrop using browns and earth tones.

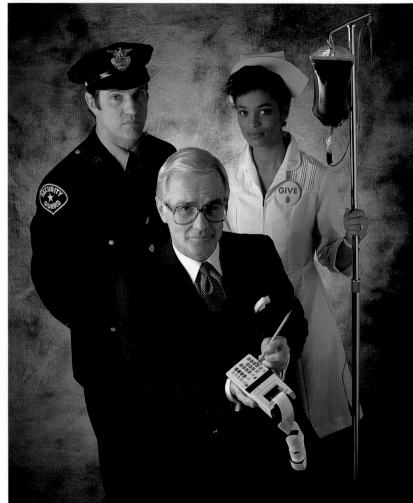

PROPPING A SCENE

Choosing the right furniture and other props for an illustration shot is extremely important. Props have to have the right "look." For example, if I want a couch, should it be an up-scale couch, an older couple's couch, Archie Bunker's couch, a blue-collar couch, a modern couch, or an early American couch? Should it be light in color or dark, a solid pastel color or patterned, full-length or a love seat? Then I have to ask: Where will I get it? Will they deliver or do I have to pick it up? Can I rent it? Is it in the budget? Can I get it by tomorrow? Being able to get a prop in a week or a day makes a big difference in how it looks. A perfect prop that is needed tomorrow and is not available until next week is a nonexistent prop. An okay-looking prop that is available now, suddenly looks more perfect than it did at first glance.

In New York City, finding accessible props is somewhat easier because there is such a variety of prop-rental companies. There are stores that have common and sometimes uncommon props for rent. Some are known for contemporary props, others for period props, furniture, costumes, artificial plants and shrubs, and other specialties. Most of these places do a lot of their business with the TV networks, commercial producers, and feature film companies. There are also several source books with suggestions about whom to try for specific props, which stores will rent, who will customize, and so on.

Despite the wide array of props available to me, I usually hire an experienced stylist to pull together the right props for the right look. For one thing, the props at several of the prop houses may not be in the condition I want. It may be that they are too worn looking, because of constant rental, or they look too new for my purposes. And even with the prop houses and source books, I always need props that are not easily obtainable. Many times the prop that appears to be the easiest to get turns out to be the hardest. Finding baseball uniforms for kids in twenty-four hours is always hard, but trying to find them in January seems to add that little extra challenge.

Most of my prop hunts are a combined effort of the stylist and my studio staff. Many times, we will split up what the stylist will get and what I will get. Because I have a house in the Berkshires, there are some props I can put my hands on that may be difficult for the stylist to find in Manhattan. Rural mailboxes are commonplace near my house but as rare as chicken lips in Manhattan.

I maintain a well-equipped prop room for props I may use over again. Many times I've made weekend trips to hunt for knickknacks, or as they are more commonly known in New York, *tchotchkes*. An antique photo of a baby, bought in a flea market for a dollar, can be put into a decent frame and used over and over again on a mantel, a desk, or a night table. Fake Hummel figures are also one of my favorite collectibles that add just the right touch to many a photo.

I try to have as much as possible in the way of props at the studio, but there is no way to anticipate every change of mind the art director may have. That's why it's very important to know my neighborhood. I know where all the stores that have men's clothing, women's clothing, kids' clothing, toys, household goods, chef's uniforms, and so on, are located. When I have a white chef's hat and the art director says, "Well, now that I see it, maybe I'd like a red chef's hat," it pays to know where I can get one quickly.

Changing props in mid-shoot seems to happen more often than one would think possible—and mostly on shoots that are scheduled for one hour. One of the reasons is that one-hour shoots usually do

not have a big enough budget to allow for more than one or two alternative items for a prop needed. On larger-budget jobs, I usually have several choices for the art director there on set. If I need a lunch pail for a kid, I will try to have four or five in different styles and colors to choose from. On jobs with smaller budgets, it is more important to have a stylist who knows what I like. She or he has to be able to get the right prop on the first or second try.

Many times on smaller-budget jobs I depend on the models to bring in their own wardrobe. If what they bring does not work out, I have to send a panicked staff person out to find what I need. I will proceed on set working with the models and props I have up until the point I need to shoot film. It usually takes me thirty to forty-five minutes to get my final lighting down and get the right expressions or actions from the models. It is during the last ten to fifteen minutes that I do my shooting.

Because of this timing, it is no problem if it takes a half hour to change a prop. When a stylist walks in with 10 minutes left to shoot, the art director, model, and I have worked out any kinks we had with the shot on Polaroid film. Whatever prop needs to be changed is changed and we proceed.

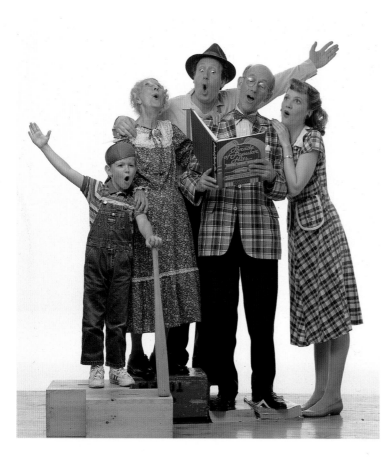

STYLING WITH CLOTHES

For this assignment I carefully mixed the patterns in the models' wardrobe to give the photo a livelier look. The art director wanted a forties or fifties look, not necessarily an authentic period shot, but something that captured the same feeling. Sometimes mixing clothing patterns can be deadly, but it worked well in this situation because it helps to keep the viewer's eye moving.

One of my objectives whenever I shoot a group of people is to prevent everyone from forming a horizontal line. Since I knew from the layout that the art director planned to crop the picture at the models' waists, I decided to elevate some of the models on boxes and phone books to form a pleasant-looking arch. This kind of arrangement is always more pleasing to the eye than a horizontal composition.

FINDING THE PERFECT CHAIR

Often I don't hire a stylist for a specific prop if the studio can locate the prop over the phone. The photo of the dentist chair was pretty straightforward. It was one shot of a three-part award-winning campaign for Crest toothpaste, which I did with art director Hal Nankin and copywriter Alan Barcus. The art director told me he wanted a dramatic light on the chair. I knew the look he wanted and knew how to get it by placing a single, large, directional light source—a large bank light—above and behind the chair to create rich shadows.

The hardest part of the shot was finding the chair and persuading someone to let me shoot it in my studio. That involved making a lot of phone calls, using the Yellow Pages, and a little bit of luck. I had initially found a chair at a medical supply company in Manhattan, but it would not let me take the chair out of the store. The store had 8-foot (2.4 m) ceilings, which wasn't enough room for me to position a large bank light. So it was back to the phones.

My crew now expanded its search to metropolitan New York and located another distributor who had in stock the type of chair we were looking for. The distributor was willing to let me rent the chair and would allow me to shoot it at the warehouse or in my studio if need be. With the deadline looming, I had only three or four more days to shoot the ad and make the placement deadlines in the magazines. I ran out to Long Island myself to look at the chair and the location. I would have preferred to shoot the chair on location because the chairs are very expensive—$20,000 to $25,000 retail—and require a technician to operate. The company had several chairs that looked good, but the location was again too small. The ceiling was okay, but there was not enough room to lay a seamless background. I took Polaroids of the chairs and sent them to the advertising agency to be forwarded to the client for approval. Once the chair was approved I made arrangements to transport it to my studio and, to have a technician for the chair present during the shoot.

LITTLE THINGS COUNT

I made this picture to illustrate a magazine article on taking care of your TV and VCR. I like the mixture of old and new in the propping of the shot: the new TV and TV stand, the old-fashioned dress on the model, the hook rug, and the feather duster.

The feather duster was the hardest prop to find for this shot. Most of the feather dusters my stylist found were the small pink ones available at dime stores. She found this one, which I thought looked more like an old-fashioned duster, in a very fine home-furnishings store. Whenever I have a hard time finding a prop, I remember how our perseverance paid off with the perfect feather duster. That prop jumps out at me every time I see it in someone else's photograph, and I think, "Wow, what a great feather duster!" or, if it's the pink variety, "That's just a cheap substitute for the real thing, the photographer should have kept looking."

Of course, the best prop for a shot often appears two weeks after the assignment is finished. That's why I maintain a prop closet. The little porcelain dogs, the baby picture, and the picture frame on the TV set are standard props I keep on hand at the studio. I've always loved the way the little dog looks up at the feather duster in this picture.

Gathering the props for the picture of the harried business man was fairly simple, but they did require a little forethought. I knew I wanted to have the type of coffee cups that local diners use, so my assistant went out and bought coffee cups at a local diner. We created the ashtray filled with cigarette butts the old-fashioned way—three of us sat around smoking our lungs out. Actually, we bought a pack of cigarettes, cut most of them down by hand, and lit the stubs. My own office provided the loose papers.

One criteria for this shot was that the set have a realistic look as opposed to the stylized look in the picture of the woman dusting the TV set. If I had shot the businessman as a stylized situation, I would have used different models who were broader in appearance, and I would have put pencils and pens sticking out all over them. The cigarettes in the ashtrays would have been piled up a foot high, the coffee cups would have increased tenfold, and there would have been three times as many papers.

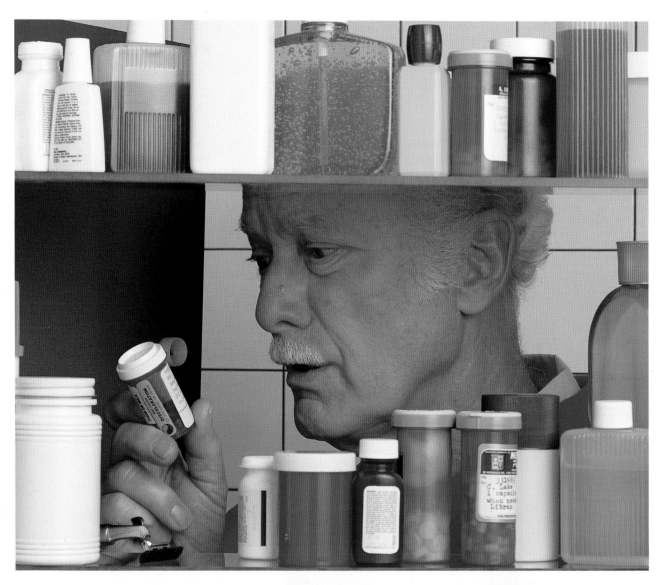

SIMPLE SOLUTIONS ARE BEST

This was a simple shot of a man looking into his bathroom medicine cabinet. The point of view is from behind the cabinet. Getting a medicine cabinet and cutting out the back of it was too messy, confining, and expensive, so I created the illusion of a cabinet instead. The most expensive prop in the final picture was the model's red robe.

The glass shelves came from a glass store I read about in the Yellow Pages (which, by the way, is my favorite source for finding props and a great way to prop up models as I did in this shot). The tile on the background wall comes in 4 × 8-foot Formica sheets that are fairly inexpensive and easily purchased at any Formica supplier or at the Set Shop in New York City. The shelves were mounted on Bogen shelf brackets attached to Bogen Super Clamps, which enabled me to adjust the height of each shelf. The cabinet has a glass door that was spray painted blue and attached to a stand with A-clamps.

BUYING VERSUS RENTING

Sometimes a prop constitutes the entire set. In this case, the bank teller's window is actually a post-office window that my stylist found in an architectural salvage store. I had rented props from this store before, but when I tried to rent this window, I found out the store had started a $500 minimum-rental policy for photographers. This seemed a little steep since the window's purchase price was $400, so I saved my client $100 by buying the window instead of renting it, and I also saved the cost of trucking the window back to the store after the shoot was finished.

The trick to setting up this situation was being able to see the female model's face and not the back of her head. For the shot where I wanted her to look at the teller as opposed to looking directly at the camera, I had her "cheat" her line of vision so that she was actually looking a few feet in front of the teller. Because film is two dimensional and everything falls into one plane, it appears she is looking directly at the teller. When I ask models to "cheat to the camera," they know exactly what I mean because they are asked to do this all the time. The photographer has to be careful in setting up a "cheat" shot because there is a point at which the model no longer appears to be looking at the other person, but rather appears to be staring off into space.

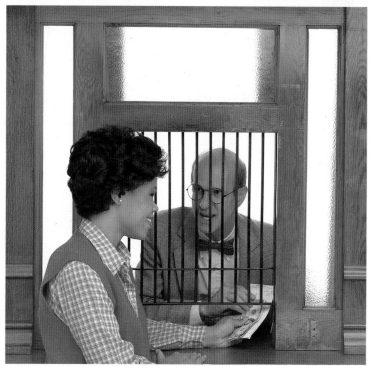

CASTING

Finding the right models, booking them, and getting them to look the way one wants are important parts of illustration photography. There are a number of ways to choose a model. The most traditional way is for the photographer to have a conversation with the art director on what type of model he or she wants for the shot. It may be a fashion look, a real-people look, an extreme character look, up-scale, blue-collar, animated, house-wife, professional, distinguished, mid-western, conservative, radical—the list goes on and on.

Once I think I understand what the art director is looking for, I call up the booking agents at the modeling agencies I think will have the people I want. I use the same descriptions just mentioned to indicate the types of models I want, and I also mention other models or actors as a reference. A film director may say "Get me a Humphrey Bogart type." Well, still photography works the same way, except the agent and I may use the name of an actor or model that we both know: "You know, someone like Ruth, but not as charactery. More middle-American, but not too up-scale or fashionable." I keep two things in mind when working with agencies: First, my taste in models may be different from the agent's. Second, agents have a tendency to send out models who are signed exclusively with their agency, as opposed to sending freelancers who are available through other agents.

After the models have been lined up, I have a "go see." Models come to the studio, and Polaroids are taken of them. The great advantage of this is that I can have the models pose for the Polaroid according to the requirements of the layout. I can now see what they look like with a particular expression, angle, or costume.

Also, using "go sees" to cast a shoot prevents me from getting a big surprise ten minutes before the shoot. For example, I've run across some older models who have used head shots that are seven to ten years old. With children, a head shot twelve to eighteen months old means I get a child who looks completely different from the photo. With young women, I need to see how much of the head shot is reality and how much is the makeup artist, the lighting, or the camera angle. A model who looks good full face may not look as good three-quarter face. Hair lengths and hair color also change very quickly.

After the "go see" session, I review the people who came for the casting and make my first, second, and third choice. The Polaroids and my list of choices are sent to the art director, who then decides on one model (who may or may not be one of my top choices). Sometimes the art director has to send the material to the client to choose.

Often the schedule or the budget does not allow for a Polaroid casting. Then I talk to the agent at the modeling agency, and he or she sends me head shots and composite pictures. If I do not see anyone I like, I call different agents for more head shots, or I call the first agents back and ask them to go further into their files. I then make my choices and forward them to the art director.

Sometimes there is no time to get composites. Then I go into my own files and pull out composites or Polaroids taken for other castings. Occasionally, an art director with whom I've worked decides to leave the casting up to me, and we have a quick discussion about models I might use. If the person we've talked about is not available, I know what to look for.

MY SHOT AT STARDOM

Sometimes castings are not just a phone call away; casting agents don't always have what I need. When Sony wanted someone with a beard for an ad, I had a hard time locating the right look. So I supplemented the casting with people I knew. I called a writer and a photographer whom I knew had the look I wanted. In the course of this search I decided that I had the right look, too, and so I had my assistant take a Polaroid of me. The art director, Eileen Walsh, also thought I looked okay for the ad, and so I was picked as an alternative, but her first choice was a model from an agency. His beard was a little too light, which I corrected with black mustache wax and a toothbrush.

I shot the model, and my assistant, Bruce Wodder, shot me. Prints were made of both of us. This finally, was my chance at being on the other side of the camera. It was a nice thought, but in the end Eileen and the creative head, Dick Thomas, thought I looked better on the working end of the camera. The point is, I'm always ready to go to whatever lengths are necessary to find the people I need.

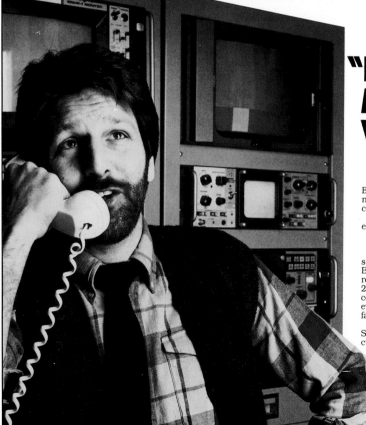

BOOKING A MODEL

Once I've found the right model, I need to put him or her on tentative hold for the date of the shooting session. A tentative hold on a model is arranged by mutual trust on the part of the photographer and the booking agent. It pays to have a good working relationship with the booking agent at the modeling agency. He or she knows that I wouldn't tie up the model's time needlessly. If something else came up for the model's time, the agent would call my studio and give me first option on that time. If I couldn't confirm the booking, I would release my hold on the model's time. If I felt there was a strong possibility that I would use that model, I would ask the agent to give me more time before I had to release the model. That is where the mutual trust comes in.

Some agents have a tendency to tell photographers that the model they and their client spent so many hours deciding on is no longer available because he or she is sick; then the photographer later finds out through other sources that the model was not sick but a better booking (one with more hours) came in. When that happens, I don't call that agent anymore. Most reputable agents will call the photographer if something better comes up to see if he or she can change the shooting day or time with that model. If a change can't be made, they honor the first commitment. I have seen several models lose lucrative bookings this way, but they chalk it up to the nature of the business they're in. The same thing happens to photographers.

GETTING A NATURAL LOOK

Most of the models I work with are professional actors and actresses. Many of them model as a sideline to their acting careers. Working with them is great, in that they understand taking directions, giving me poses that may feel awkward to them but that look correct in camera. They are real professionals. Working with a good actor can turn a normal four-hour shoot into a two-hour shoot. But photographers do not always have the luxury of working with actors and actresses. Some of the models at the modeling agencies are not actors but full-time models. Also, some do modeling as a sideline to another career or as a diversion from retirement. A photographer can sometimes end up with a "stiff."

What do I do when I have a stiff on my hands and I have to get a very natural, unposed look for my photo? What I do is talk—a lot! I try to have a conversation with the model, whether the model is a three-year-old child or a seventy-year-old retiree. There is always a common ground to talk about. The important thing is to start the person talking, feeling relaxed, and looking natural.

In some cases, I suggest that the model repeat a nursery rhyme, such as "Mary Had a Little Lamb." I like to have models actually talk, not just mouth words, because talking always looks more natural. Small children may not be able to recite a nursery rhyme. Then I will play "Simon Says. . . ." I have them say vowels—"Simon says 'A.' Simon says 'E.' Simon says 'I' " and so on. This generally loosens them up. With adults who are not models but are "real people" as photographers call them, I will try to find out if the person has a hobby or has taken a vacation recently.

The true professionals are great. They get right into character. If they are playing a business person, they will try to sell me the product. If there are two or more models, good models will try to improvise a scene with their colleagues. Bad models will stand there with a big empty smile on their face. I hate shots that have three or four people sitting around a table with big empty smiles on their faces. None of them look as if they are really talking or laughing at a joke; instead, they all look as if they've just been stuffed by a taxidermist who decided to put a smile on their faces.

My professional goal is to make people look lifelike in my photographs. Along with talking, body English is very important. Because the camera tends to tone down everything, I have to get the models to exaggerate their expressions, gestures, and poses. It's a lot easier to tone down something that looks too extreme on the set than it is to liven up a model that looks like a cadaver.

I don't usually use makeup people because I generally photograph natural-

looking people, and I want them to look natural. I do powder my models with facial power if they are shiny. The worst thing for me to see in a photograph is skin that shines—I think it looks just awful. I like a matte skin on my models. When I do use a makeup person, I like to get someone who has a really light touch. For most of my pictures, even the ones that require a lot of makeup, I still like a natural look. Barbara McKay, the model in the picture on page 52, was in makeup for almost an hour, and she still looked very fresh and natural, not overly made up.

When hair-and-makeup artists or their representatives call for an appointment to come to my studio to show me their portfolios, I try to explain to them about the kind of work I do; otherwise, they will bring a book of just fashion and beauty shots. This won't tell me what I want to know because I rarely use heavy beauty makeup on my models.

PULLING PUNKS OFF THE STREET

This picture was great fun to cast. When I first received the layout for this Sony ad, I thought I would have to check out some punk bars to find the person I needed, but after some calling around I was able to get punks from both Heidi Kert at Funnyface models and Liz Ames at Gilla Roos models. Liz is a rock and roller herself, and she asked a bunch of her nighttime friends to come to my studio for the casting.

During any type of casting session, the trick is being able to project a model's face into a visualization of the final shot, which in this case meant seeing a model as a punk even if the model came to the casting in a business suit. This isn't as easy as it sounds because everyone has prejudices and first impressions that are influential. A good casting person has to be able to see beyond that.

Eddie Horror, the model in the picture, didn't come in a business suit, but he was rather quiet and reserved; however, he was enthusiastic and had, by far the best haircut. The hair-and-makeup artist, Nancy Berg, did a lot to enhance Eddie's natural endowments—he was a great foundation for her to work with. I think this shot was the most fun my stylist, Cathy Lake, ever had styling, and the shooting itself was a lot of fun for me and for the art director, Eileen Walsh. The shoot reminded me of an air-guitar contest.

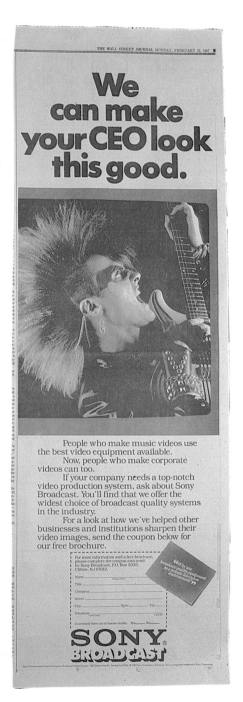

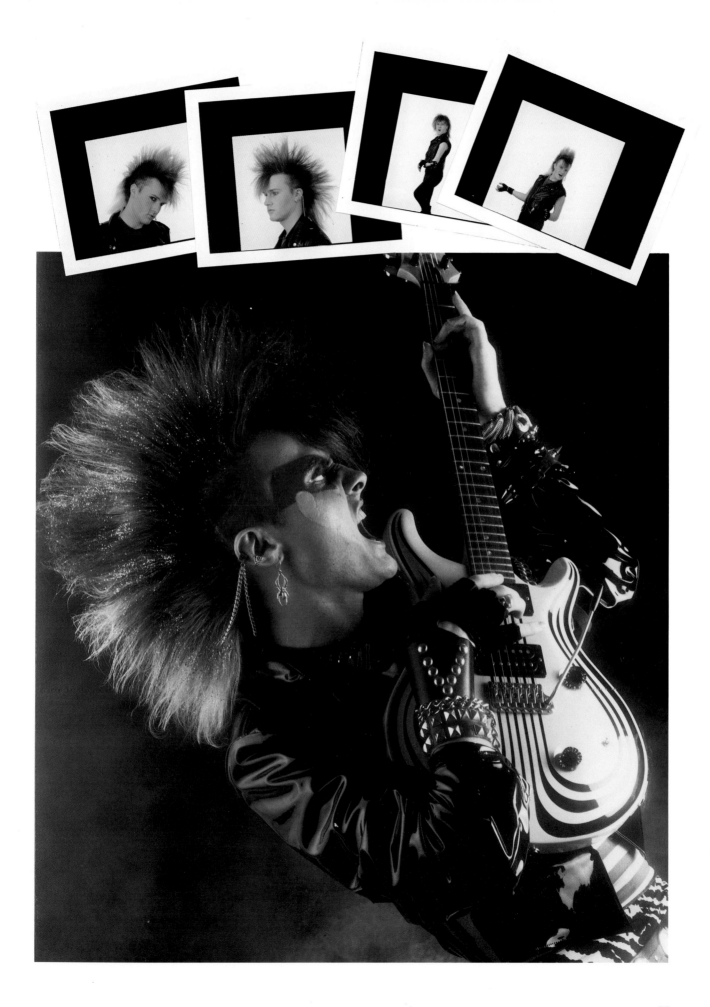

A RARE MEDIUM WELL DONE

This shot works so well because the model, Zoya Leporska from Funnyface models, was so perfect for the part. The photo was commissioned by an editorial publication. The art director, Eileen Goldstein, sent me a layout with the instructions that the crystal ball should be as large as possible so that it would be the main attraction. She was going to strip existing art of upcoming products into the crystal ball, so it was important to make the ball as bright and white as possible. She also didn't want too much in the background. I decided that the crystal ball should be the main light source—it would look more natural and make it easier to strip in the products for the article.

Since the shot was editorial, the budget was limited. Casting was done by calling in head shots from modeling agencies. Looking at the selection sent to me, I ran across Zoya's head shot and decided she was far and away the best "fortune teller." Since she was not a model I had worked with before or had remembered from a previous casting, I called her agent, Heidi Kert at Funnyface, to ask if Zoya could come in for a "go see." I wanted to make sure she looked like her head shot. When Zoya came in, she looked perfect, with the exception of her short fingernails. She was booked for the shot and I paid for the application and removal of long nails by a manicurist.

The wardrobe and props for the shot were a bit overdone, because of my belief that the camera tends to tone down most looks. It is also a lot easier to start off with more than is needed and then take it away. It's a lot harder to add what isn't already there. In this type of situation, a dark and moody shot, less is not more. A "normal" amount of jewelry would have left the model looking bare on film.

The crystal ball was provided by the magazine. It had a flat bottom and a lot of air bubbles, that disappeared when the ball was lit. As the layout showed, I tried putting the crystal ball on a pedestal, which consisted of a 2-inch (5 cm) core taken from a roll of gaffer tape. The core was covered with a cloth, leaving the bottom of the core open to allow a light to shine through and light the ball.

The ball and pedestal were then placed on a ¾-inch (1.9 cm)-thick piece of Plexiglas that acted as my table. The table was then covered with cloth arranged in folds around the ball. A strobe head was placed underneath the table and aimed at the crystal ball. It was a good effort, but it didn't work. The opening of the pedestal wasn't big enough.

I took the ball off the pedestal and placed it directly on the Plexiglas. This helped. It now lit up the fortune teller's eyes (as played by my assistant). But the ball was still not bright enough. I tried a reflector card behind the ball, but that didn't catch enough light. I then tried a piece of diffusion material instead of the reflector and added a second light with a spot grid underneath and behind the ball, aimed at the camera. This worked beautifully.

I put a reflector card overhead to fill-in the model's face slightly and placed a light behind the model, aimed at the background to separate her from the painted canvas backdrop. I diffused the image by adding a Hasselblad softar #1 filter and a Harrison #2 filter to make the crystal ball "glow."

As a variation, I also took some shots with a bank light overhead. Eileen Goldstein used them as filler shots throughout the printed article. I didn't like them as much because they were more open and not as dark and moody as the other shots. The magazine did use the darker version for the main opening shot.

The shooting went quite smoothly, Zoya being very much a pro who got right into character. My only disappointment in the shooting was that I never got my fortune read.

Gypsy peering into crystal ball looking at video products

8½ x 11 full bleed

Zoya's agency sent me this composite card when I began to cast for the fortune teller.

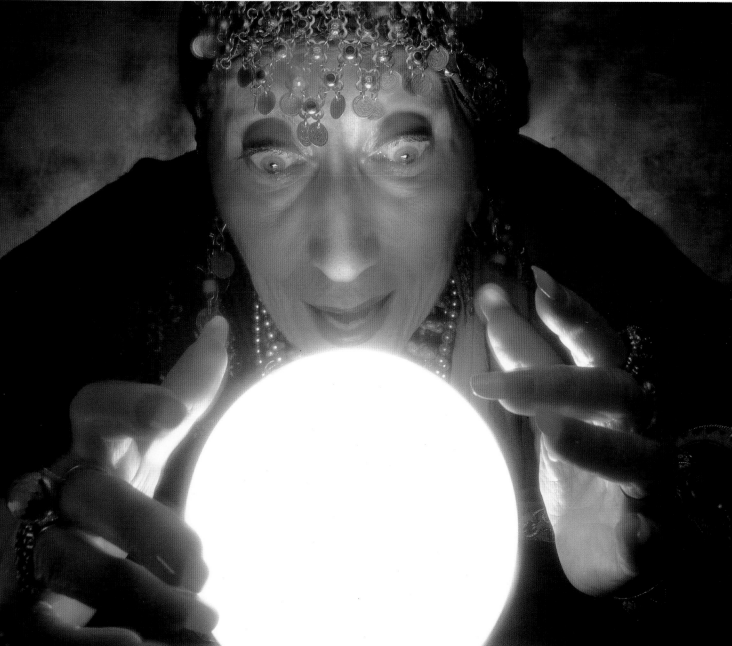

WORKING WITH CHILDREN

Whenever I am photographing children, I always make sure there is enough seating in the studio. Four children are generally accompanied by a minimum of four adults. Every once in a while, my staff forgets to inform a model's agent that the child is limited to one parent or guardian. This mistake can lead to breaking local fire department regulations about crowds in public places. I have had some children bring grandparents, parents, siblings, neighbors, and sometimes, I think, even their mail carrier. Once I had one model bring two grandparents, one parent, a younger sister, and a baby with a wet diaper. Imagine all these people hanging around the studio as I am trying to shoot an ad while entertaining the art director, who brought along a writer, account executive, assistant account executive, client, and one other mysterious person.

It takes a certain kind of personality to be able to do good illustration photography with children. One way photogra-phers can find out if they are suited to this kind of work is to gather three to five children ages eight to twelve and try to coordinate them to produce a photograph or even to play a game. Photographers who don't have the right temperament or chemistry for child photography will soon find it out. Without this special chemistry, any other advice or suggestions about photographing children are useless. Threats, bribes, pleas, and promises may be acceptable to parents but won't cut any ice with the child. Using chairs or whips on the child may have some effect but won't be acceptable to parents.

The only survival tactics for photographing children that I can make with a clear conscience are the following:

1. For young children age two to six, try to shoot in the morning when they are awake and active.

2. Check local child-labor laws and follow them.

3. Treat children as people: Talk to them, and ask them how their day was. My fa-

My work often brings me face to face with the future.

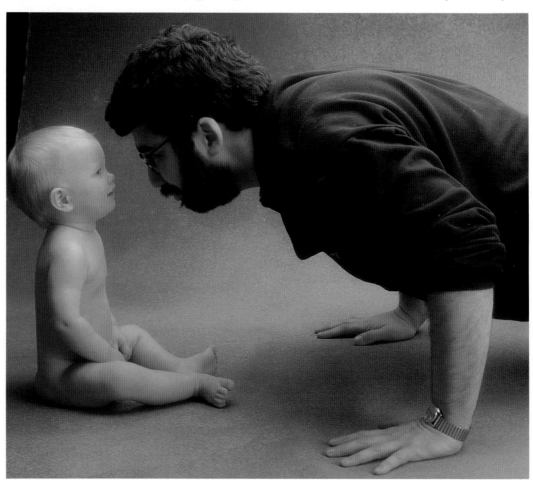

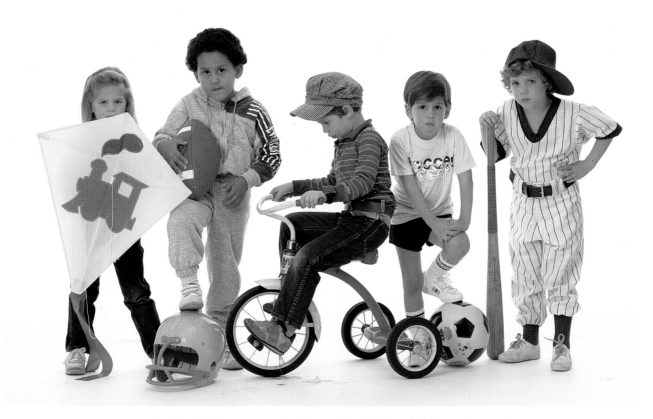

vorite question for school children is, "What did you learn in school today?" Eighty percent will answer, "nothing." Ten percent will give me a good answer, which tells me I have a child of above-normal intelligence. It is the 10 percent who answer, "I don't know" who are going to be my biggest problem. At least the majority who answered, "Nothing" knew what they learned and are average.

4. Write the names of the children on a piece of tape and place the tape in your line of vision, on the camera or a light stand. (For complicated shots, I sometimes take a Polaroid and my assistant writes their names on the Polaroid and places it in my line of vision. I do this with adults, too.) Children are much more responsive when addressed by name.

5. Have something ready for your throat. I am always hoarse after working with children. I tend to talk a lot, to talk loudly, and to repeat what I say when I shoot. There is always one child who needs more attention than any of the others. "Joey, keep your head up, keep your head up, keep your head up!!" This command is spoken rather quickly. Some children don't react until the third command.

6. If you don't like children, don't shoot children. It will show. If you do like them, it's hard work, but you'll enjoy it and find the resulting photographs personally satisfying.

7. Don't be afraid to let someone else trip the shutter if the baby relates to you. I let a lot of my assistants handle the camera if I think I need to be off-camera, playing with the baby in order to get a reaction. I do this mostly with small babies, 6 to 8 months old. They sometimes are fascinated with my beard or glasses, or they may be frightened by them.

8. Buy toys to have around the studio. Having something to play with keeps older children (age three to eight) occupied and not bored. I also have a variety of toys to get the attention of babies. Keys, real or plastic, seem to intrigue most of them. I tape the keys to the end of a pole and place it between the baby's line of sight and the camera so that the baby looks in the direction of the lens. Sometimes I even have the mother stand next to the camera in order to get the baby looking at it. But most of the time I try to hide the mothers in another room, so they won't distract either the baby or the crew.

A STORY WITHOUT WORDS

I loved this assignment. Ed Mazon, an art director doing a direct-mail brochure at Reader's Digest, called and said, "Jack, shoot some kids for me in baseball uniforms choosing up sides for a game with a bat. Shoot it like a Norman Rockwell." There was no layout.

The casting was done with an eye on getting a visual variety of kids. During the casting, my staff took information on the boys' heights and weights.

Ed couldn't make it to the shoot. It's not unusual for an art director who is a frequent associate not to show up (in a way, it's a vote of confidence), but it happens even more often when you're shooting more than one child. However, if you are shooting a girl in a bikini, this problem disappears, and another one surfaces—are there enough chairs for everybody? For this job, every boy brought one adult, all of whom sat quietly in the other room while I tried to get the shot.

The shooting was completed in the hour I had allocated in the budget. As you can see from the outtakes, I made the most of that hour. I had the boys try several different situations, some with just two of them, some with three or four, changing the way they wore their hats, and so on. The final shot was one of the last frames I took. Everything seemed to fall into place as I looked through the viewfinder. The kids framed the bat, and all the visual elements important to telling the story were arranged in a tight circle on the upper third of the frame.

This is one of my favorite photographs in my portfolio. The emotions in it and the story it tells appeal to my sensibilities, and it appears to my eye to look natural and unposed. I may pull out half my hair giving directions during a shoot like this, but the results are worth it.

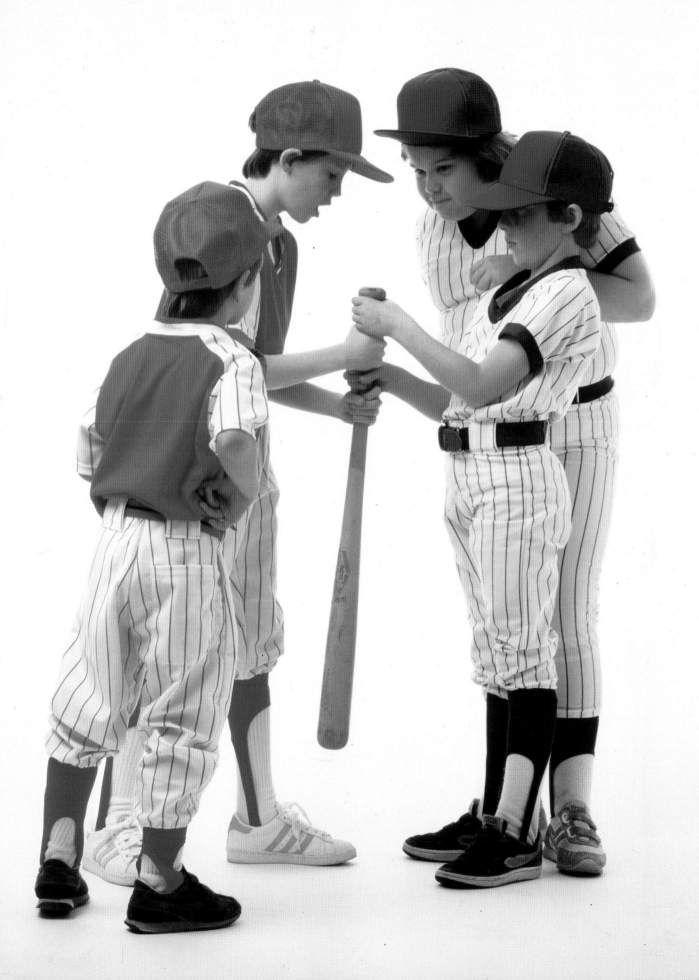

MOPPING UP PROBLEMS ON THE SET

If I am photographing infants who aren't wearing diapers, as in some of these American Baby ads, it's important to have *quick* assistants. The backdrops for the babies were rented—expensive rentals for expensive backdrops. Think about it. These kids weren't housebroken (that's why babies wear diapers). This is where my quick assistants came into play with paper towels in hand. From experience, I can say that Bounty *is* the quicker-picker-upper and is the paper towel of choice on my baby shoots.

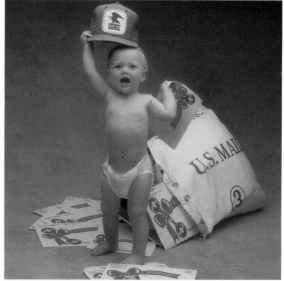

DIRECTING ANIMALS

Photographing animals is a lot like photographing little kids. Animals have a short attention span, they come to the studio with a human mommy or daddy, and they sometimes get nervous and forget they're housebroken, just like little kids. In many respects animals are easier to work with than children because animals don't cry and lose control of themselves. When a kid gets bored or tired and starts crying, that's the end of session for that child. An unhappy dog, on the other hand, just walks off the set, a problem easily solved by the trainer who puts the dog right back in. Trainers who work often with the same animals develop great rapport with them and know how long they can stay on the set and repeat a trick. If a trainer feels the session is taxing the animal's endurance, we end the shooting. The dogs usually get bored and begin walking off the set after one or two shots, but we just keep puttnig them back, and I end up shooting the job one frame at a time.

A lot depends on what the animal is required to do. Getting a dog to lick his chops is very easy. I always keep some liver pâté in the studio when I shoot dogs, and I rub a small piece of it on the dog's nose or mouth. This keeps the dog licking for at least four or five frames. Butter or margarine also works, and I always check with the trainer first to make sure it's okay to feed the dog either pâté or butter. Dogs have different kinds of stomachs, just as human beings do; what is okay for one dog may be indigestible to another. I also keep a bowl of water nearby in case the dogs get thirsty.

Almost all the animals I photograph come to me through an animal agency.

The person I contact most frequently to get animals is Linda Hanrahan at a company called Animals for Advertising. If I need to cast a dog that can do a certain trick, such as singing or holding something by the mouth, Linda sends me photos of the dogs that are available; then I show my client what these dogs look like. If I need a particular breed of dog, such as a St. Bernard, Linda locates a well-trained St. Bernard.

The St. Bernard with the glasses on had what Linda called a Ph.D. in obedience. I immediately knew that was the St. Bernard I wanted. Who wants an over-sized obedience-school dropout in a photography studio?

If I need a dog to do a very specific trick, I ask an animal talent scout to find a trainer who can train the dog to do it. The real trick is being able to give the trainer enough lead time to teach the dog; some specialized tricks require weeks of preparation. More often though, I simply hire a dog to act as a prop. For instance, the picture of a boy in his room is more appealing with the extra added touch of the boy's best friend.

Cats are almost impossible to teach; they just do as they please, as all cat owners are well aware. It is possible to teach some cats to do very simple tricks, but if they are spooked on set, they forget all their training, and there are many things that occur during shooting sessions that will spook them.

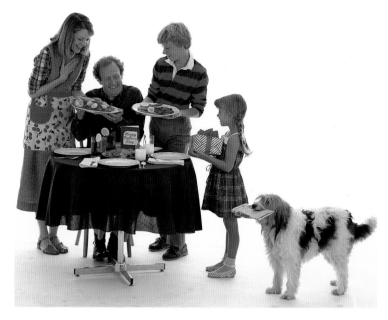

When I get a layout that shows a small child playing with a puppy, I get nervous. Directing either one separately is hard enough, but putting a child and a puppy together on the set is the photographic equivalent of playing with dynamite. All I can do in situations like this is to try hard and give the assignment my best shot. Putting a hot dog on the end of a stick is wonderful for distracting a dog, but directing a kid is another matter. I always warn art directors who give me such layouts that a lot of what they're looking for has to be left up to chance. But when the moment is right and I capture it on film, I've made a magical picture that has universal appeal.

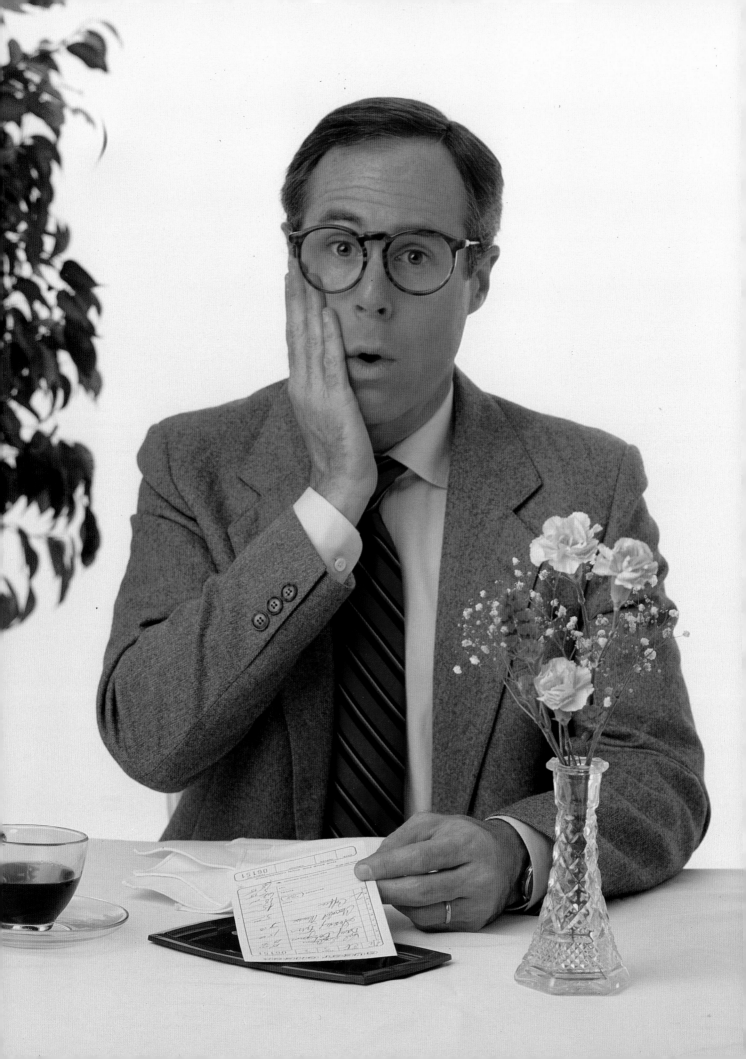

ESTIMATING A BUDGET

When someone asks me out of the blue, "How much do you charge for a photograph?," I like to answer, "How deep is the ocean?" Ask a loaded question, get a loaded answer. There is no straight answer to this question; like most commercial illustration photographers, I don't have a standard charge.

Commissioning a photograph is not like ordering a meal at a Chinese restaurant. The client doesn't place an order by saying, "Let's see, I'll have a portrait from column A and a product shot from column B, and oh yes, can I see the dessert menu?" Just as an 8 oz. soft drink can vary in cost from ten cents (when served from a two-liter bottle bought in a supermarket for sixty-nine cents and served at home) to five dollars (served at a nightclub I'll never go back to again), the price of a photograph can vary. A high-school portrait for a yearbook and a portrait of Lee Iacocca for a Chrysler ad bear the same relationship as a McDonald's hamburger and a steak at The Four Seasons restaurant. The difference is in the overhead, the materials used, and the final result.

Which brings me back to the basic question, how much should a photographer charge? Well, even though I don't have a standard price, I do ask my clients standard questions. I need these questions answered after I get a layout so I can make an intelligent estimate. I do an estimate on almost every job I shoot in order to give the client an idea of how much the photograph will cost. First, I must know how the picture will be used and for how long so we can negotiate usage rights. Is the picture being made for an editorial publication, a consumer ad, a trade ad, a free-standing insert (one of those coupon sections in the Sunday paper or in a magazine), a billboard, a poster, or a newspaper ad? How long does the client want to use this photograph—one year, two years, forever? Do they want regional rights for one city or one part of the country, or do they want international rights? Then the question of overhead comes into view. Does the client have a budget in mind: Will the picture require a complex set, or can the shot be easily styled? Are there any special effects involved? Prestige is very important to some clients who want to spend lavishly on their advertising because their companies have designated a large budget for advertising certain products.

When I am asked to estimate a layout for a picture I must find out whether the layout is written in stone. Does the shot have to be exactly like the layout, or does the layout give a general idea of how the shot should look or feel? It is really important to clear up any ambiguities about the layout before going ahead and estimating a budget for the shoot.

After I have received a layout, know the picture's usage and the length of time it will be available to the client, and understand the lavishness or simplicity of the production required, I can work on pricing it. Photographers gain experience at pricing the same way people learn about sex: they talk with their peers, listen to a lot of tall tales, make a bunch of mistakes on their own, and then they learn. Some photographers learn faster than others, and almost everyone expands the truth a little bit.

There are two parts to any estimate: the creative fee and the production expenses. Photographers base their creative fees on their experience at pricing photography jobs as much as on their experience behind the camera. Depending on the photographer and the advertisement involved, a creative fee can vary from $1,000 to $10,000. However, the variable that really changes the most from estimate to estimate is the production expenses involved. One photographer might see an ad as a location shot, while another might see it as a studio situation. One might know where to find a particular prop, while another might want a prop maker to build it. An estimate shows an advertising agency just how the photographer is going to approach the assignment, which in turn affects how much the production will cost. For instance, my approach to photographing the floating woman wearing the x-ray apron on page 87 made my estimate $2,000 less expensive than the next lowest bid for the job.

Although it may seem trivial, there is an important difference between the terms "bid" and "estimate." A bid is always an estimate, but an estimate isn't necessarily a bid. Whenever you provide prices for a client, you are doing an estimate, but if other photographers are also doing estimates for the same job, then your estimate is a bid. If you are the only photographer providing an estimate, then it is simply called an estimate.

In this business, terminology is very important because misunderstandings can be expensive for everyone. If your bid on a job is approved, then the estimate you offered becomes your budget. When the agency calls your studio to hold a date for the shooting session, you need to know whether the job is definitely or only tentatively yours. If the job is still being bid, their holding date may be tentative; the agency may be covering its tracks by making sure that the photographers who are bidding are also available on the day the agency wants to shoot. On the other hand, if you definitely have the job, you are entitled to a cancellation fee if the agency cancels or changes the shooting date without giving you forty-eight hours notice.

It's not safe to assume that the photographer who offers the lowest bid will always get the job. If an estimate is too low, an agency may be concerned that it won't get the production values that it wants in the photograph. An agency doesn't want a cheap-looking picture delivered to its client. While agencies do tell photographers who are bidding on government accounts, such as ads for the army or the post office, that the lowest bid will get the job, this shouldn't be seen as the norm. In fact, sometimes the reverse is true, and the agency and client go with the highest bid simply because they want a particular photographer. Agencies that know who they want to use and ask other photographers to bid anyway conduct such a bidding simply to compare photography prices. Phony bidding isn't only unfair, it costs the other photographers a lot of money. Putting together an estimate can take anywhere from two hours to an entire day of a photography staff's time, not to mention the phone bills for compiling the necessary information.

At my studio there are some standard lines of communication between the agencies I work with and me and my staff. Basically what this means is that my sales representative, or "rep," handles all the financial communication and negotiations, while I handle the creative dialog with the agency. The flow chart shown here diagrams who talks to whom once a job has come into the studio.

The process begins with the art director who has a layout and needs a photographer to produce the illustration. The art director contacts the art buyer, who is in charge of the financial paperwork at the agency. The art buyer negotiates the prices and terms for the agency, issues a purchase order to the photographer, and goes over the bills after the job is finished. Sometimes the art buyer is also the one who shows a photographer's portfolio to the art director. At some agencies the art directors depend on the art buyers not only to do the financial paperwork, but also for bringing them creative options. An art director may ask an art buyer, "Which photographer would be right for this job?" If the agency doesn't have an art buyer, then the art director usually handles most of the art buyer's functions.

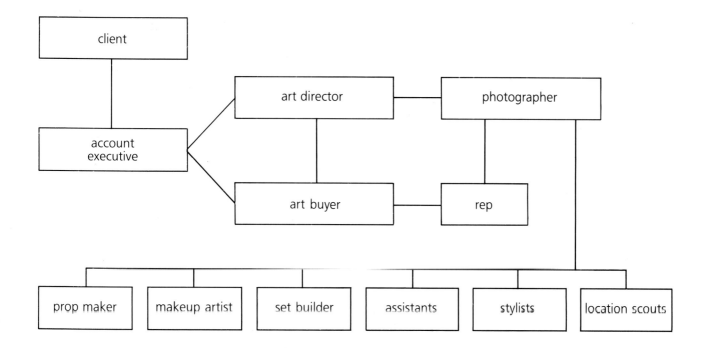

When the art buyer gets a job to be estimated or bid, they contact my representative, Elyse Weissberg. Elyse tries to get as much information as possible about the job. She asks the art buyer such questions as whether the agency is asking for a bid or an estimate, who the other photographers we are bidding against are, what usage rights are involved, whether the photography will be black and white or color, and whether the background is a set or is seamless. She tries to anticipate any questions I might have about the layout. It's amazing how many times someone forgets to tell us whether they're talking about a black-and-white or a color job. Also, if the photograph will become a large billboard or is an action picture, I might want to use a particular film format, which would affect our estimate.

After Elyse gets all this information and a layout, she contacts me, the photographer. I in turn call various support people, such as my stylist, a set builder, or a prop maker, to see whether they're available to work for me. Sometimes the Yellow Pages helps me locate a place or a vital prop for the shot. After I get as much information as possible from my expert support network, I contact the art director with any artistic questions or problems I might have encountered in my research. If I have any financial questions, I contact

my rep, who in turn contacts the art buyer. When I have questions that only the client can answer, the art buyer or the art director routes them through the agency's account executive who is handling that client's account. Finally, my rep and I work up the estimate or bid, and she presents it to the art buyer.

If at any time before or during the shoot I am asked to do anything that would incur an extra expense not included in my estimate or bid, it is my rep's job to contact the art buyer immediately and see if the overage can be approved. For example, the art director may decide at the last minute to include a gold-plated kumquat in the picture. The art buyer will either say, "fine, it's okay for the budget," or "forget it," at which point I have to spray paint that kumquat. Sometimes the art director will decide on the day of the shoot to do a small still life, called an insert shot, along with the ad. This involves a new fee, and if I don't negotiate for it before I shoot, I will be in a terrible bargaining position. Clients who are inexperienced on the set also occasionally ask me to do an additional shot "since you have all your equipment set up." My rep tells them that there is an additional fee for the shot, and then she negotiates for it. I wait until she feels it's okay before I go ahead and shoot it. Art buyers rarely veto additional costs as long as they are

This flow chart shows the lines of communication between everyone involved in making a photograph for advertising.

told immediately why we are incurring the overage. Generally, an increase within ten percent of an estimate doesn't have to be approved. Ten percent is an accepted variance within the industry, but I consider it good business practice to inform the art buyer of any increase.

Carefully going over the agency's purchase order for the photography is also very important. There may be terms in the purchase order that are objectionable or onerous, and it is up to the photographer either to renegotiate or amend the purchase order accordingly. Anything I write on the purchase order will supercede anything previously written. If the purchase order says the agency has all rights to my photograph and I have negotiated trade usage for one year with the art buyer, and it is written on the purchase order as trade usage for one year, the only rights I have given away are trade rights for one year. Verbal negotiations aren't worth the paper they're written on. I must have the final arrangement in writing on the purchase order, either typed or handwritten by myself, my rep, or the art buyer before I sign the purchase order.

It is also important to know the difference between selling "all rights" and doing a "work for hire." If I sign a work-for-hire agreement, I am giving up my copyright and all the rights to that photograph. If I want to use that photograph in my portfolio or in a promotion piece, I can't do so without the copyright owner's permission. The photograph is no longer my property. But if I sell all rights to the client, I can still retain the copyright and the ownership of the photograph. I try to sell only the rights the client will be using—for example, national consumer, local trade, billboard, direct mail, or editorial rights—and I also try to limit their duration—for example, eighteen months, one year, or two years. If the client wants all rights, I charge accordingly. As a photographer I am selling the rights to my photographs, not the physical photographs themselves, so I find it vital to spell this out and sign all my invoices.

Rights and copyrights can be very complicated. There are even lawyers who aren't familiar with the copyright laws and don't understand their implications for photographers. I've heard of one photographer who sued a client for using his photograph on a package without his permission. His lawyer sued for his regular fee in what amounted to a theft-of-service suit. What the lawyer should have sued for was copyright infringement, and he should have pursued it as a federal case. This would have entitled the photographer to much greater damages for unauthorized usage of his photograph. Copyright violations rarely happen with advertising agencies because their paperwork usually covers everything, and they are very sophisticated about the copyright laws.

Outside the agencies there are a lot of copyright abuses. There was one photo-realist painter who copied a photographer's picture from an ad and turned it into a photo-realistic painting, right down to the client's product in the ad. The photographer sued and not only won a substantial settlement, but whenever that painter exhibits the painting, the photographer's copyright must appear with it. There was also another case that involved a photographer copying another photographer's picture of a girl on a diving board for use in a sun-tan lotion ad. In what was a clear case of plagiarism, the original photographer sued under the copyright laws and won a settlement as well as the ownership of the copyright to the other photographer's picture.

This area of photography is worth a book by itself. I recommend that photographers who need more information contact a photographers' trade organization, such as the Advertising Photographers of America (the APA), which has chapters in New York, Chicago, Atlanta, Los Angeles, and San Francisco.

AN INEXPENSIVE SOLUTION

If I hadn't known the usage for this layout, I would have approached the estimate differently and lost the bid. The layout the agency gave me was for a "sell sheet," meaning it wasn't intended for use in a magazine ad but as a handout for salespeople. The layout looked simple enough—a woman against a white background, floating about 5 or 6 inches (12.7 or 15.2 cm) above her shoes, illustrating how light her lead-lined X-ray shield was. But I knew that having the model jump wouldn't work because then I couldn't control her hair or her clothes.

When I called special-effects people about rigging the model in a harness and floating her like Peter Pan, I was given prices that ranged from $2,000 to $4,000 plus the possibility of having to rent a sound stage with a grid (pipes below the ceiling used to rig lights) to hold the rigging. There would also be fitting time for the model before the shoot in order to custom fit the harness.

Knowing that the shot would probably be killed if the client saw what it would cost (although sometimes clients fool me), I studied the layout again and came up with another solution. Since the model was being shot against white, it would be easy to take two shots and assemble them. The line made by the skirt would be a perfect place to reassemble her legs with a minimal amount of retouching. I called the retoucher I work with to discuss any problems that I might not be aware of. He told me it would work better on 8 × 10 film than the 4 × 5 film I was thinking of shooting. As I said, it pays not to assume anything. The cost for the assembly would be $100 to $150—that beat $2,000 to $4,000.

I called the art director to find out what final piece of artwork she was going to give the printer—a dye transfer, a chrome, or a print. She told me a dye transfer. That meant I didn't need to have an assembly chrome made at my retoucher; the art director could have her dye maker assemble the elements when he made the dye. I could therefore shoot the job on 120mm film with my Hasselblad. Since 120 film is less expensive than 8 × 10 film, that meant an even bigger savings in film costs for the client.

I sent in an estimate for the job that was $4,000 less than the other photographers' bids, so I was awarded the job. It might not have been produced at all if I hadn't brought the costs down. Because I shot the model's legs with the skirt raised, I was able to add more leg than there was in reality. This was visually more pleasing to the eye. Even the model, Valerie Marsh, was extremely pleased with her leggier look when she saw the Polaroids spliced together.

Style and comfort that seems to defy gravity!

Well not exactly defy gravity. But our Wolf Protective Wraparound Apron and Vest, with its innovative two-piece styling, distributes the weight of lead protection where it's most comfortable: at the hips as well as the shoulders. This unique design also allows for maximum flexibility and uninhibited movement.

The Wolf Wraparound Apron and Vest set comes in royal navy or rich burgundy and both are durable and stain resistant for years of satisfied use. Both Apron and Vest come with convenient velcro fastenings for easy adjustment and quick on/off use.

Relax in a Wolf Wraparound Apron and Vest set; you're getting maximum lead protection in comfortable two-piece styling. Like all our protective aprons it's backed by Wolf X-Ray's 50 years of commitment to quality.

Your Wolf representative would be happy to "float" by and arrange a fitting.

Wolf

MAKING MAGIC LOOK EASY

When I was contacted about doing this ad, one of the most important things I was told was that the ad would be used in trade magazines. They usually have small circulations, which ultimately makes their ad's budgets smaller. After looking at the layout and talking about it with the art director, I was ready to figure out how to do this job and to estimate its cost.

The first thing I did was eliminate the idea of shooting on location and sending location scouts in search of a good "castle-looking" room. The location fee and transportation would have been too expensive even if the room were found. The second thing I did was scratch any plans for building an expensive set. Since including a window would have meant using a set builder (at $350 a day plus a tool charge and possibly an assistant) and a backdrop to put behind the window to make a realistic view, I vetoed a window. I decided that a one-wall set composed of a rough plaster wall would look right. There were going to be rough-hewn pillars in the wall, but I decided at the last minute, along with the art director, that the look was wrong and that the pillars were distracting wherever they were placed.

I knew that Jan Laighton, the model, would be perfect to play the alchemist. His long, angled nose would be effective over his beard. Jan is not only a great model, he also does his own makeup and gets his own wardrobe—in fact, he already had the beard and the wig. He's a model, a hair-and-makeup artist, and a stylist— a triple-threat model—which contributed to why I chose him.

Before I submitted the estimate, I called Jan's agent to make sure he was available. (It would have been very unprofessional to suggest a model to the art director and client, only to find

out that that model was out of town or booked for the next three weeks.) When I found out that Jan was available for the date I was aiming at, I placed a tentative hold on that day. If someone else wanted that day, I would have had first priority. I also negotiated a price for Jan at that time so I knew what to put in the budget.

Two estimates were prepared: One if I used Jan, and the other if I had to cast for the alchemist, rent a wig and beard, allow fitting time for the model for the wig and beard, and hire a makeup artist. I knew the estimate with Jan was more attractive, but the pitfall I was watching out for was that the client might not have liked Jan. If Jan had not been approved, then I would have been stuck with an estimate that was approved but unworkable.

Another aspect of this job that needed more thought was the pouring of the alchemist's molten gold. Any layout that shows a liquid being poured sets off alarms in my head. The problem I faced with this shot was that too much time, effort, and film would have been wasted trying to get a good pour from the ladle.

It was time to call in Mark Yurkiw, the model maker. He would make a solid pour of liquid out of a substance known only to model makers, enabling the alchemist to place the ladle above the "pour" and look as if he were pouring molten gold perfectly each and every take. Mark would also make the gold bricks, which, I instructed him, were not to be perfect. I wanted them to be irregular with rounded edges and chips in them. I discussed these requirements with him in person and over the phone after I had sent a layout to his studio. He gave me a price, and I put it in my estimate.

I then called in a stylist to go over the propping and to estimate how much the props were going to cost and how long it would take the stylist to find them, since stylists are paid by the day, not by the project. We also discussed whether any of the props might be a problem and whether we had any alternatives. The table, for instance, would have been too costly to locate, rent, and send back and forth. I therefore decided to build a table out of planks of barn wood on sawhorses. After all this legwork and thought, I still didn't know if I was going to get the job. It could have been canceled for whatever reason.

In the end, of course, I did get the job. The shoot itself was typical in the last-minute adjustments and running around. The liquid in the cauldron was made by gluing plastic, with ripples, onto a piece of cardboard and painting it brown. The cardboard had two sides cut smaller than the cauldron so that smoke, created by dry ice in a tray of warm water, could rise up like steam. Anyone who has worked

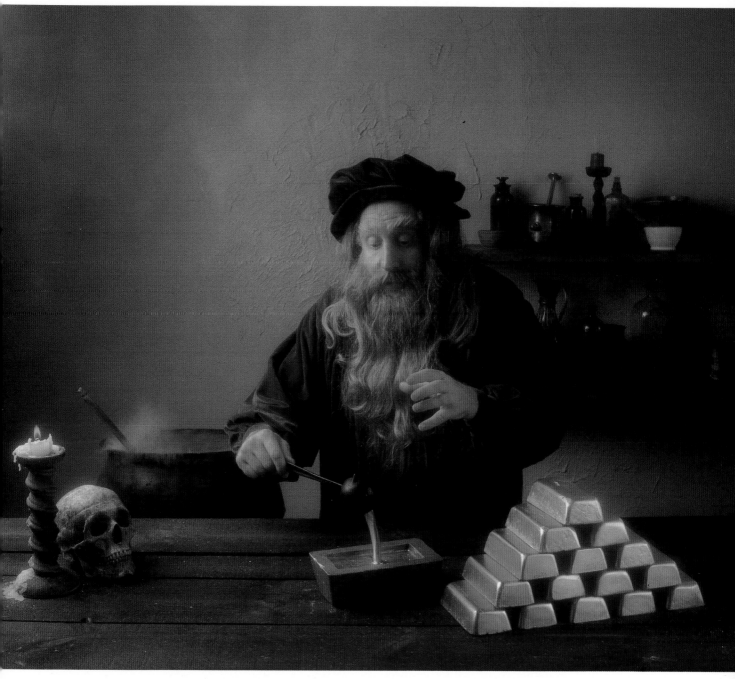

with dry ice will recognize the problem I ran into—the smoke from the dry ice wouldn't rise but rather settled on top of the cardboard "liquid." I had an assistant stand off the set and blow into the smoke with a long straw, spliced together from three regular straws, and that created the rising smoke I wanted.

I also used a smoke machine to add smoke behind the model. I waited to shoot until the smoke dissipated into a fine mist. This seemed to create more distance between the subject in the foreground and the wall in the background.

The lighting for this shot was one large banklight, as close to the model as possible, on the left side of the set. A piece of cardboard block-ing the spill of light from the bank to the back-ground created the shadow on the back wall. A small silver reflector, about 12 × 18 inches (30.4 × 45.7 cm), on the right side of the set, helped the gold bars to "pop." The lighting effect I wanted to create was that of a single, large light source, a window, in a dark, moody interior. More light sources or more fill to open up the shadows on the right side wouldn't have been correct for the look or mood I wanted. A slight diffusion was used over the lens along with an 81C warming filter. After several days of preparation for this kind of shot, it's great to peel off the first Polaroid and watch the art director's eyes light up.

PIECING CLEOPATRA TOGETHER AGAIN

I did another job, which called for Cleopatra rolled in a rug, the same way as I shot the floating woman shot but for different reasons. Although stripping three images together was a lot more expensive than making one shot, the three shots gave me better control of how the final product looked.

When I first discussed the shot with the art director, we decided that we would have to strip in the feet, since it would be hard to find the proper rug in a width that allowed the model's head and feet to be seen. If I found a 5-foot 7-inch model, I would need a rug 58 inches (147.3 cm) wide. For a 5-foot 10-inch model, I would need a rug 60 inches (152.4 cm) wide. It was going to be very complicated. Besides, the Oriental rugs that were available to me for rental were much more limited in choice of width, and they started at about 84 inches (213.3 cm) wide. (Buying an Oriental rug was out of question because of the cost.)

I was given approval to use a beautiful 84-inch (213.3 cm) rug and had it delivered to the studio so I could experiment. I rolled myself into it first to see how it was done. I felt like a hot dog in a straitjacket. My assistant then rolled it around her. She looked like a pinhead. During another call to the art director, we decided to strip the model's head and feet onto either end of the rolled rug—the size of her head and feet could then be controlled. I would also need less time with the model and makeup person because we were now doing a head-and-feet session, which would be more comfortable for the model. The rug was shot on 4×5 film, and the model's head and feet were shot on 120mm film. When the art director assembled the elements, the picture looked perfect.

An irresistible package gets you through to the toughest customer.

Getting through to Caesar looked impossible, so Cleopatra created a package that was truly irresistible. Today's direct marketers need to be just as daring. With Westvaco, you can be. Because we'll match you idea for idea.

At Westvaco, we help designers and producers of direct marketing campaigns find original, inventive ways to get their messages across. By engineering envelopes that stimulate curiosity and action.

We have the capability to produce the envelopes you need. Then we make them available to you through any of our 24 locations across the country. Special

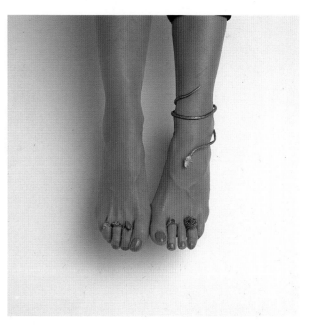

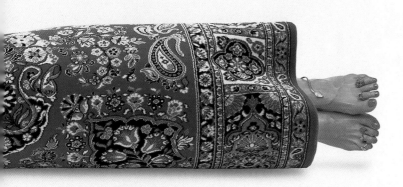

sizes. Unusual shapes. Windows of all kinds. Envelopes with action devices like labels, pull tabs or punch outs. Envelopes within envelopes. Colorful envelopes. Envelopes that look like leather. Or linen. Or even an oriental rug.

So let your imagination run wild. Then run your ideas by Westvaco's Creative Engineering Center. We'll find a way to make them real. Call 1-800-628-9265.

(In MA, 1-800-332-3836.) Or write Creative Engineering Center, Westvaco-Envelope Division, 2001 Roosevelt Avenue, P.O. Box 3300, Springfield, MA 01101-3300.

Westvāco
Envelope Division

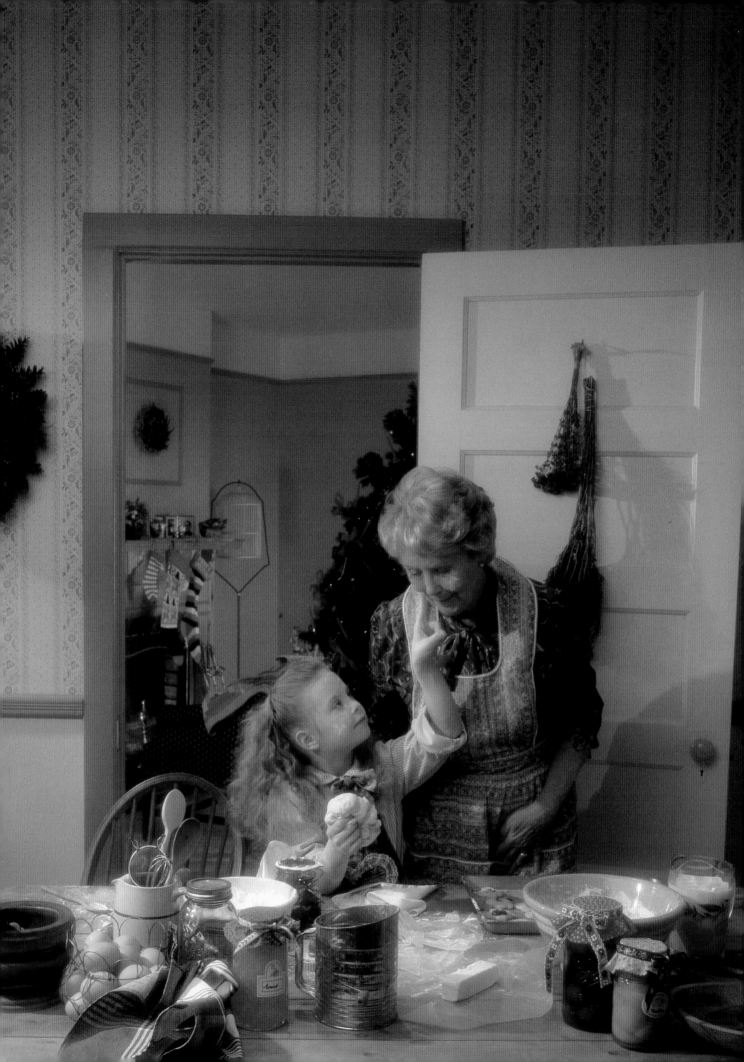

PRODUCTIONS

The first half of this book is similar to the parts of the elephant described by the blind man. Now that all of the body parts have been cataloged, I'd like to present a more integrated view of what this elephant looks like and how it moves by talking about specific problems I've encountered and how I solved them. Some of the specific problems may not come up again during my lifetime, but new problems seem to come up with every other assignment I get. The important lesson is to think the problem through, and to notice the thought process involved.

A lot of us complained in high school and college that the problems we were given for homework had no connection to reality. I mean, who uses algebra in everyday life? Who cares that a train leaves Los Angeles at 7 AM, and another train leaves New York at 4 PM? Well, the problems themselves were never the point. It was the process of finding the answer that was important. The fact is that some answers didn't surface in a straight-line progression; sometimes they had to be extrapolated. Being a good commercial photographer means more than being a good photographer—it also means being a problem solver.

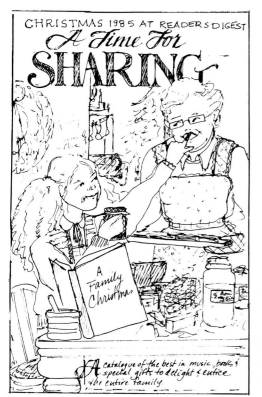

A TIME FOR SHARING

To photograph this Christmas baking scene, I had a fairly elaborate, two-room set built by Stephen Shapiro, who is a very good film-union set builder. Carpenters don't have to belong to a union to work on a still-photography set, but hiring a union set builder is a plus because that person is already very experienced at building photographic sets.

Even though the back room is the smallest part of the picture, creating it required the most effort. The room was important because it helps establish that the characters are in someone's home, giving the picture a sense of depth and realism. By putting a Christmas tree in the back room and hanging stockings over the fireplace, I was also able to provide a seasonal reference for the picture.

When I go to the trouble of building such a complicated and expensive set, I don't want to lock myself into only one point of view—I want as much flexibility as possible. That's why I had the kitchen wall built much larger than the part of the wall that shows in the final picture, just in case I wanted to change my shooting angle or use a wider lens.

THE YOLK'S ON YOU

The "egg on the face" shot was a great concept from the art director, but it was the type of food shot that can keep a photographer up nights. It required me to collect all the ingredients I thought I would need beforehand and correctly mix them with the art director, account executive, and others looking over my shoulder.

As with most ads, the deadline was such that there was just enough time to get the props together, never mind pre-testing them. A food stylist fried the eggs the night before, and I had them very carefully messengered over to my studio (another important tool for a photographer is a great, not just good, messenger service). They were completely immersed in oil, in large Tupperware containers. Because of the possibility of spilling yolk on the model's clothes, I had to include money for suit rental and dry cleaning in the estimate. And just in case the real eggs didn't work, my assistant went looking for fake eggs in joke shops. She did manage to find fake eggs, with clear whites, and attached shells. I thought they might make a good alternative.

"Now you tell me about 575 Fifth Avenue."

All the necessary ingredients were now collected—eggs, model, crew, agency people, film, camera, lights. Now to mix the ingredients. First question: Do I place the model on his back and shoot down? No! Problems with lighting—a drop shadow behind him. Also the egg will follow gravity, and the look might be that of an egg thrown at him. It might, however, be an alternative if all else failed.

I decided to tilt the model's head slightly and shoot from a higher angle. The yolk would break from behind and ooze down his face, but I didn't care because the yolk was on the model! Surprisingly, the eggs did not slide that much, but they did not have the right look. I took plenty of good shots, but I felt I didn't have it in "the can" as they say in film.

I went and looked at the fake egg. Not too bad. I shot it as is—clear white and egg shell. Using the fake egg, I could put putty on the backside of the yolk and attach it to the poor model. I took some shots while one of the assistants took a second fake egg and sprayed the clear whites with white spray paint. The egg shells that were glued on were carefully cut away.

In my hand, this ersatz egg did not look healthy, but on two-dimensional black-and-white film, it looked terrific. And I could control the shape of the egg on the model's face. I took a few shots with one eye just looking out over the egg. Even with the egg balanced on his nose and most of the "egg" an inch or two off the model's face, with a long lens (150mm on a 2¼-inch Hasselblad) and lighting so there was no shadow, the illusion was one of an egg on someone's face. It is a case of a fake looking more correct in the camera than a real object. This image in my portfolio always gets a great response from art directors—I guess because it's such a recognizable image of a well-known saying.

real egg

fake egg

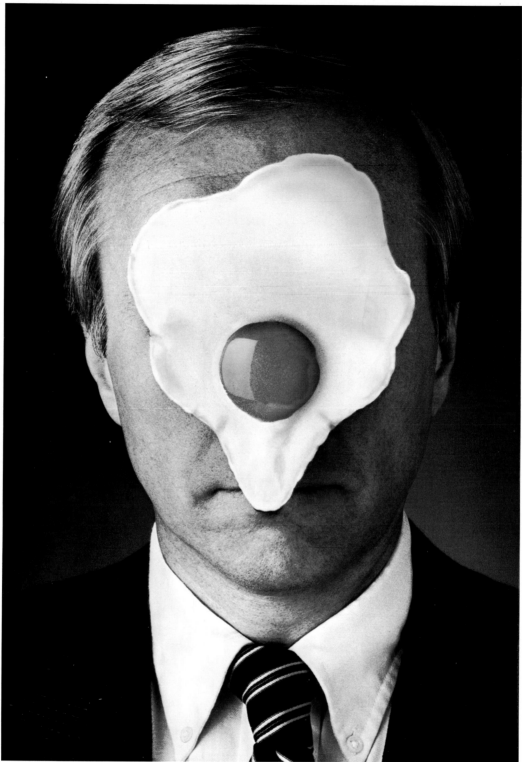

"Now you tell me about 575 Fifth Avenue."

Pity the businessman who's got a bad case of egg on the face. He's just signed a lease in Midtown without first investigating the extraordinary opportunities at 575 Fifth Avenue.

This architecturally distinguished new office building still has space available.

And we would wager that this superbly located building is priced *below* what even a savvy Manhattan real estate expert would expect.

Indeed, rarely does an opportunity so financially *and* aesthetically rewarding present itself.

That's why Cosmair, whose trademarks include L'Oreal, Lancome, Biotherm, Gloria Vanderbilt, Ralph Lauren, Chaps, Guy Laroche, Cacharel, and Paloma Picasso, has selected 575 Fifth to be its new U.S. headquarters.

For more information, either call Cushman & Wakefield or have your broker contact us.

We hate to see a successful businessman sporting a sunnyside up on his face.

575 FIFTH
THE SMART BUSINESS MOVE.

CUSHMAN & WAKEFIELD ®
A Rockefeller Group Company

the first layout

the revised layout

the final ad

PYROTECHNICAL PRECISION

I enjoyed this assignment to photograph an arsonist because it literally allowed me to play with fire. Well, not personally, but I did get to direct the pyrotechnists: "More fire! More fire! No. Wait. Less fire! Less fire!!"

As you can see from the first layout, when I received the job, it was fairly tame: an arsonist setting fire to a box, with a can of gasoline next to him. After a discussion with the art director, in which I explained that I could get a large, controlled fire and have a lot more drama, he agreed to my idea and came back with another layout. "Oh boy," I thought, "We're going to have fun now, but not in my studio we aren't." Even though I knew the fire would be under control, with all precautions possible, my sprinkler system would have gone off.

Finding a good location initially seemed like no problem. A call to one of my location services put me touch with a huge, empty warehouse on a pier. It had at least 40-foot (12.2 m) ceilings and lots of clear space all around. Along with the rental fee the owner of the warehouse only wanted a certificate of insurance from my agent.

A call to my insurance agent. No problem. Insurance would not be too expensive, a few hundred dollars. But I would have to have a fire truck and crew standing by.

A call to the fire department. No problem. They do it all the time. I would have to pay for an off-duty fire crew of five, and the department would throw in the fire truck at no cost. Also my pyro man would have to be certified by the fire department.

A call to my pyro man. No problem. He is already certified. A call back to the fire department. "By the way," they said, "we have to inspect the warehouse beforehand."

A call to the warehouse owner. Now I had a problem. The owner did not want any fire inspectors looking at his warehouse. The area we were to shoot in would be okay, but what if they saw something somewhere else they didn't like? No inspection, no fire truck. No fire truck, no insurance. No insurance, no location and no shoot.

Back to the phones. One of the phone calls I made was to the New Jersey Film Commission. (Almost every state has a film commission. They were created to help promote filming in their respective states, because filming brings in lots of revenue, directly from the film productions themselves or indirectly from tourist dollars once people see how great their state looks. Filming a TV show such as "Miami Vice" in Florida has added many dollars to the local economy.) The New Jersey Film Commission was very helpful. They put me in contact with the Newark Fire Department, which had a "fire

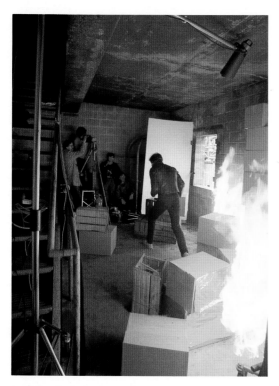

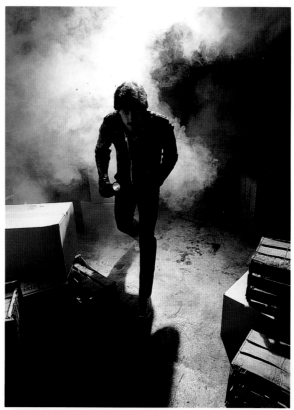

building" at their training facility. This building was constructed solely to be set on fire, for fire-fighting drills. Since it was built to burn, I would not need any insurance other than the liability insurance I normally carry.

I sent my assistant there to take location photos to show the client. The location looked great and was quickly approved. So we made the arrangements with the Newark Fire Department, packed our bags, and off we went. Our bags contained eight propane tanks and accompanying hardware to make the fire, several fire extinguishers, dozens of empty boxes and crates of various sizes, which were to be put together at the location, strobe lights, film, cameras, extension cords, and the rest of the circus.

The lighting for the shot was just a single strobe head with a paper cone on it to keep the light from getting too broad. I wanted it to look like a single bare bulb. The fire provided a lot of ambient light for fill. We also used a 4×8-foot $(1.2 \times 2.4$ m) piece of foamcore to get some additional fill.

The fire was created using U-shaped pipes on wheels. The pipes had holes in them to allow the propane to escape. The pyrotechnist and his assistant would light the propane and control the size of the flames by means of a valve regulating the flow of propane. The only problem I hadn't anticipated was the lack of oxygen in that small room when the flames were on full blast. The fire was literally taking our breath away. It was the middle of winter, but the heat in there was enough to melt the plastic around the metal frames of my glasses.

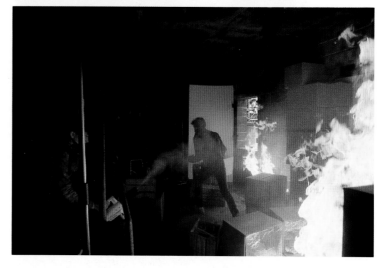

During the shoot I put aluminum foil on the back of the cardboard boxes near the flames, on the side facing away from the camera. This helped to keep them from catching fire. A few did catch every so often, and so we wouldn't lose them, one of the assistants would put out the flames with a fire extinguisher. I also brought a hand-held smoke machine to create smoke and atmosphere. I didn't want fire with no smoke. Or smoke without fire. The art director, Frank Bernaducci, told me another photographer bidding on this shot had estimated it by using just several smoke machines. There had been concern that it would look like a bad, foggy night in London.

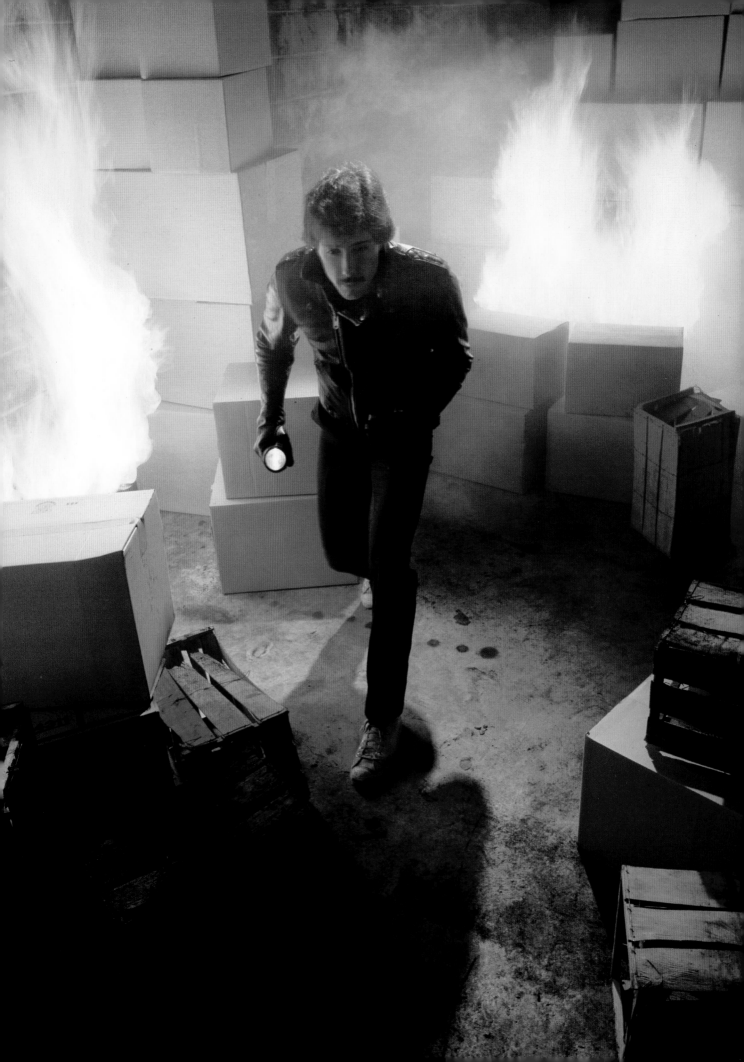

Four years later I found myself back in Newark doing another fire shot. Joy Masoff, a designer I often work with, remembered the arsonist shot from my portfolio and wanted me to do a shot depicting the Biblical story of Shadrach, Meshach, and Abednego surviving the fiery furnace for a brochure promoting a Reader's Digest book, THE ABC'S OF THE BIBLE.

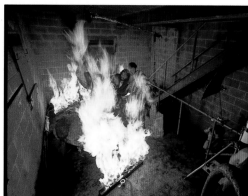

This time there were a lot fewer phone calls for getting permission to shoot again, and we used Plexiglas boulders instead of cardboard boxes. This made the shoot more difficult because if the Plexiglas boulders caught fire, they produced noxious fumes. The backs of the boulders were covered with aluminum foil. After each burst of fire, which lasted about four seconds, the pyrotechnist went around and checked the boulders and the models to make sure that they weren't getting too hot.

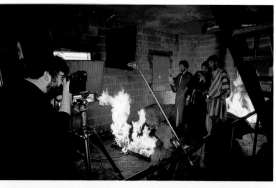

When you find a location like this, it's important not to burn your bridges, since you never know when you might have to come back. If I hadn't been up front with the Fire Department regarding what we were doing, and if I hadn't acted as courteously and professionally as possible, they could have easily said no the second time I needed to do a fire shot. Sometimes the biggest problem I face at a location is a previous photographer who was rude and unprofessional to the authorities.

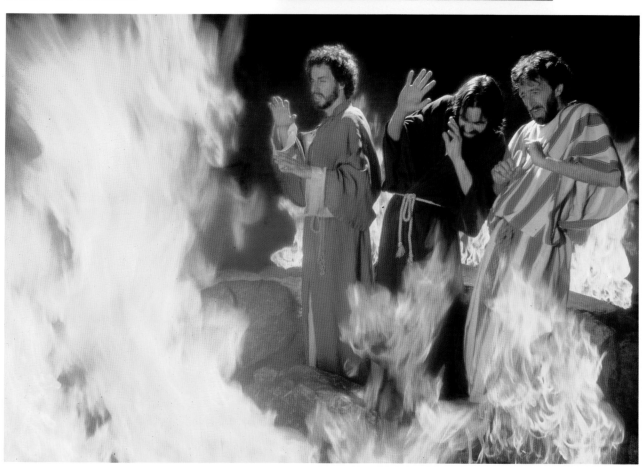

DRESSED FOR SUCCESS

This photograph was created as much by my insurance agent as by the art director or me. The original concept was to show an android-looking robot (head, torso, arms) sitting in a desk chair. The original layout did not include a desk. A desk and filing cabinet were decided on over the phone in discussions with the art director. We felt that the extra props were needed to establish the fact that the robot was in an office.

A good-looking robot is apparently hard to find. My model maker didn't have one, nor did any of the prop houses or costume suppliers I called. After a lot of phone work, including a call to Western Costume Company in Hollywood, I located a display company in New York City that rented robots to exhibitors for trade shows and conventions. They said they had what I needed—an android-looking robot that could sit. The budget for the ad was estimated to include their fee of $1,000 for the robot rental.

As soon as the budget was approved, I called to arrange for the rental of the robot and to take a look at it. I hadn't bothered to look at the robot beforehand because I wasn't sure this was going to be a job until the estimate was approved. The studio had already invested a lot of time on this project and had had many of these kinds of estimates not turn into jobs. I was also in the middle of several other projects during this time. I just assumed that the robot would be all right.

Well, you know what happens when you assume. It seems the company that had an android robot that could sit—now that the job was approved—had, in fact, a robot that *might* be able to sit. The person at the other end of the phone said I should talk to his robot supplier in Chicago. The man there said, "No problem." (After a while I get to feel that everyone I talk to has spent a lot of time in Jamaica, where the national slogan is, "No problem.") He would send me brochures and a videotape on his robots and I could choose which one I wanted. I gave him my Federal Express number, so I could receive it overnight.

The videotape arrived. Problem. Wrong look for the robots. Instead of looking like C3PO *Star Wars* robots, his robots looked like futuristic TV sets with arms. They had no legs, just a broad base with wheels. The company did have the trashcan type of robot (similar to the *Star Wars* character R2D2), which the agency thought might be usable. I fought against using it because it would not be an instant "read." Anyone looking at the ad might think it was a fancy vacuum cleaner left in an office by a cleaning woman.

Back to the search. At the eleventh hour the ad agency came up with a robot. A TV production company, known for fabricating its own props and special effects, had the perfect robot costume. The rental would be $2,000, and although in costume, the model could not sit, it would look perfect.

I then suggested that the robot stand next to a water cooler. A water cooler was a great symbol of an office and would be that instant read I thought was important. The idea of a water cooler was approved along with the additional cost of the robot. Part of that cost would be offset by eliminating the office furniture. A water cooler is a lot cheaper than a desk, chair, filing cabinet, and desk accessories and a half day of a stylist's time to pull it all together. A water cooler is just a single phone call away.

After a week, everything was coming together nicely. Until I got to the insurance. The owner of the robot costume wanted a $100,000 insurance for it. I carry what's known as a Bailee policy on top of my normal insurance policy. A Bailee insurance policy provides coverage (in my case $5,000) for any props or equipment in my possession, either in the studio or on location. If an assistant drops a $1,000 prop and breaks it, I'm covered. I'm mad as hell, but I'm covered. But a $100,000 is a whole different kettle of Kodachrome.

I called my insurance agent, Jacob Schulhof, who I'm sure looks forward to hearing what I want to insure next. "Jacob, I need to insure a robot costume for $100,000 for two days." Jacob's a real pro, not even a chuckle, but lots of questions. How big is it? How heavy is it? Does it come with a handler? How is it being transported? What is it made of? And so on. After a few more phone calls, I had all the information he wanted. After Jacob got the information, he called the underwriter and got the best deal he could. For a $100,000 policy on a robot it would cost me $900 and a $2,500 deductible.

I called the agency to explain that along with the additional $900 for the insurance, I would need a letter from them assuming the $2,500 deductible. I could not be left responsible, since I was being exposed to this liability in order to complete a job for the agency's client. It was the morning of the shoot when I received the letter. I called Jacob, who drew up a certificate of insurance made out to the robot's owner. The certificate was delivered to me, and another messenger with a truck came to pick up me, the certificate, and a check for the rental. Off to get the robot. To Jacob's relief I had no problems, although I almost drove away without the keys to the drum cases that held the robot. I didn't notice the cases had locks until I was about a block away.

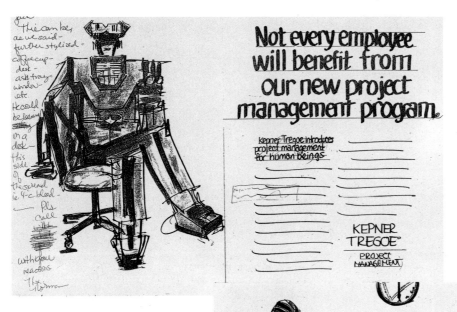

Not every employee will benefit from our new approach to project management.

Kepner-Tregoe has designed a new program exclusively for human beings.

If that sounds somewhat silly, just think back to a recent project in your organization. Odds are it didn't go the way it should have. And, in all likelihood, the reason was that the people involved didn't get along the way they should have.

So while our new program was created to emphasize the technical skills, it makes sure not to ignore the interpersonal ones.

On the technical side, participants will learn how to apply Kepner-Tregoe's proven methods in three critical phases of project management: Defining, planning and implementing.

Through our renowned processes in problem solving, they'll learn how to keep projects from going off track—and how to get them back on when they do.

And they'll learn these principles on the ultimate practical model: their very own projects.

As for the interpersonal skills, participants will learn the art of listening, how to resolve conflicts, improve performance of workers, stimulate creative thinking and other proven skills all designed to create a healthy team attitude and ensure success.

But the fact that it's a complete program isn't the complete story. Kepner-Tregoe did extensive research among two thousand companies, which revealed a very basic need: A project management program that's basic. So our new training is just that, which makes it perfect for anyone involved in a project.

And to be sure we were right, we tested our new program for a full year in real situations in organizations of all types.

And now, we're ready to offer it to you. It's available through public sessions, programs run by our professionals at your company, and through Kepner-Tregoe's exclusive train-the-trainer technique, so your staff can teach in-house.

If you have human beings working on your company's projects, they're sure to benefit from Kepner-Tregoe's new approach.

If you find they don't, you may want to check for a pulse.

PROJECT MANAGEMENT
KEPNER TREGOE

For a free video preview, information about public sessions or a visit from a consultant, call

1-800-223-0482
(In New Jersey, call 1-609-921-2806)

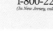

I rushed back to the studio and started unpacking the robot costume. We had only an hour to figure out how the costume fit on the model. No instruction book comes with custom props like this. (I once had to shoot the Alka-Seltzer stomach and had to have my model maker take it apart so that I could see how it was wired and so it could be operated without blowing the lights.) Some of the robot's parts were a little worn, so I had to call the owner to see if it was okay to spray paint and touch up the worn pieces and to see what kind of paint had been used. Just as I thought, it was Krylon silver. The model was procured by the agency in order to save some money. He had to be 6 feet tall and slender. The crew managed to put the costume on him just as the people from the agency and the client were arriving.

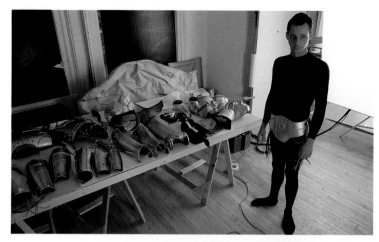

Now, after all the preparation work, it was time to take the photograph, which turned out to be less than 10 percent of the job. The lighting was all set when the robot was ready, a large 4 × 6 foot (1.2 × 1.8 m) vertical bank on the left side and a smaller 3 × 4 foot (0.9 × 1.2 m) vertical bank on the right side provided fill. I felt that a reflector for fill on the right side would have been too weak. The background was lit about 1⅓ stops more than the subject. I put a red coffee cup in his hand, rather than a white or silver cup, to give a spot of color in a basically monochromatic picture. The rest of the shoot was spent trying to get a realistic, relaxed attitude from the robot.

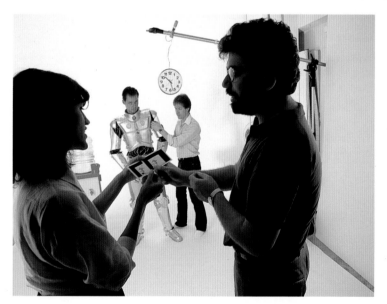

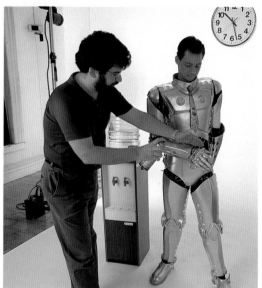

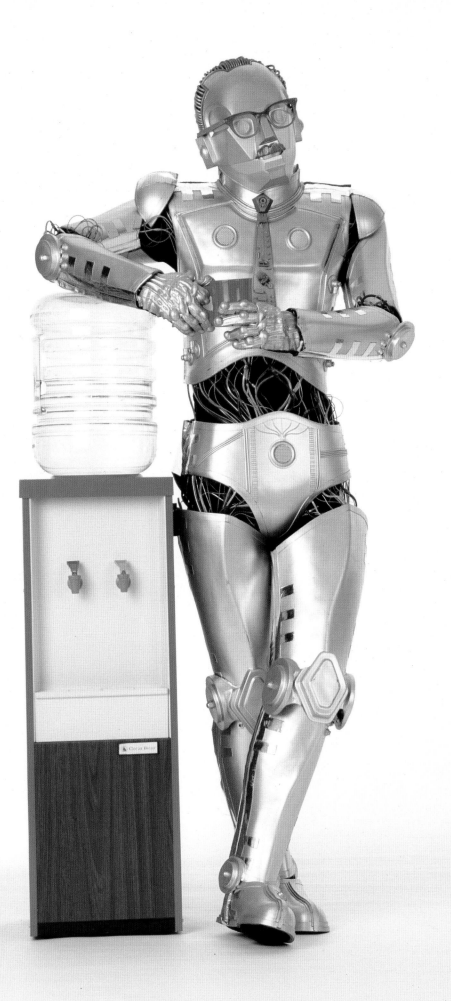

CHANGING THE WEATHER INDOORS

The man in a car on a rainy day is a studio shot created for a laxative. (I know, I know; please don't write to me. I just shoot them, I don't explain them. The truth is, this was one of several shots that showed stressful situations.) It happens to be one of my favorite shots, because of the look of it and the casting. The model had two of the saddest eyes I've ever seen. He was great at looking miserable.

Although it rained on the day I did this shot, it would have been a disaster to have tried to shoot outside. I knew from the beginning that it had to be a studio shot. I knew a photographer who had a ground-level studio with a drain, and I knew a special-effects man who could handle the rain. He was able to produce several types of rain.

My assistants made sure my strobe packs were away from any water, although one very good assistant in his excessive zeal covered several of my strobe packs with plastic. After I had taken several rolls of film, one of the packs overheated and "blew." Anyone who has ever heard a capacitor in a power pack blow up, knows that at that point we didn't need the client's product.

The two headlights in the background were two strobe heads about 25 feet (7.6 m) behind the model. I used "slow" strobes, ones with a flash duration of about 1/250 to 1/300 sec. They gave the rain its blur and hence its movement. Whenever a shot is made "through the rain," it has to be lit from behind or the raindrops will be invisible.

I lit this shot to look as if the driver were driving at night, since there is no sunshine during a rainstorm. I used umbrellas on the left side to appear like another car's headlights at an intersection. I wanted a harsh light on that side. On the right side I used a softer, weaker light, a medium light bank, to look like a streetlight or lighted storefront to create a fill.

I also used a very weak light from the camera position in order to get a "catch light" in the model's eyes. Without a catch light, the model's eyes would look too dark and lifeless.

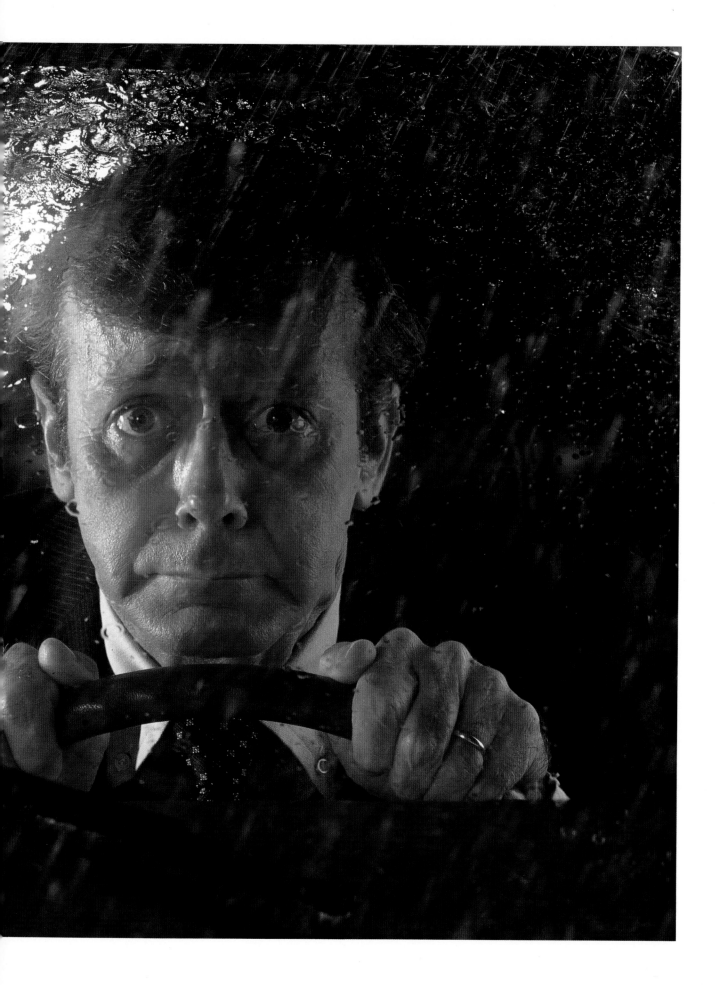

RIGGING THE SET

Rigging a set can be a lot of fun. "Rigging" is actually a catch-all phrase for describing whatever needs to be done to make an object appear to be moving on film even though it's perfectly still on the set. I love rigging problems.

Lipton Soup gave me a challenging assignment to show coupons flying around a store manager's head. This shot would have been impossible to make by simply dropping coupons around his head or tossing them up in the air. The odds were that the best shots would have included a coupon right in the middle of the model's face or that the coupons would have looked great, but the model would have been blinking. The only way I felt I could do it was to shoot against a white background and suspend the coupons with monofilament (fishing line). Shooting against white usually camouflages monofilament lines on film.

Each coupon needed two lines attached to it to keep it from spinning. Putting a piece of wood lattice above the model's head enabled me to tie off the monofilament and raise and lower the individual lines. The art director only had a few sample coupons, so I had color photocopies made on a color copying machine. The background shot shows how it looked from behind. Note that the model's smock is ironed only in the front where the camera can see it, not in the back where it will never show. (It's nice to know I can get away with that now. When I was a kid my mother would never let me get away with something like that. Even though no one would know or see the mess under my bed, I still had to clean it up.)

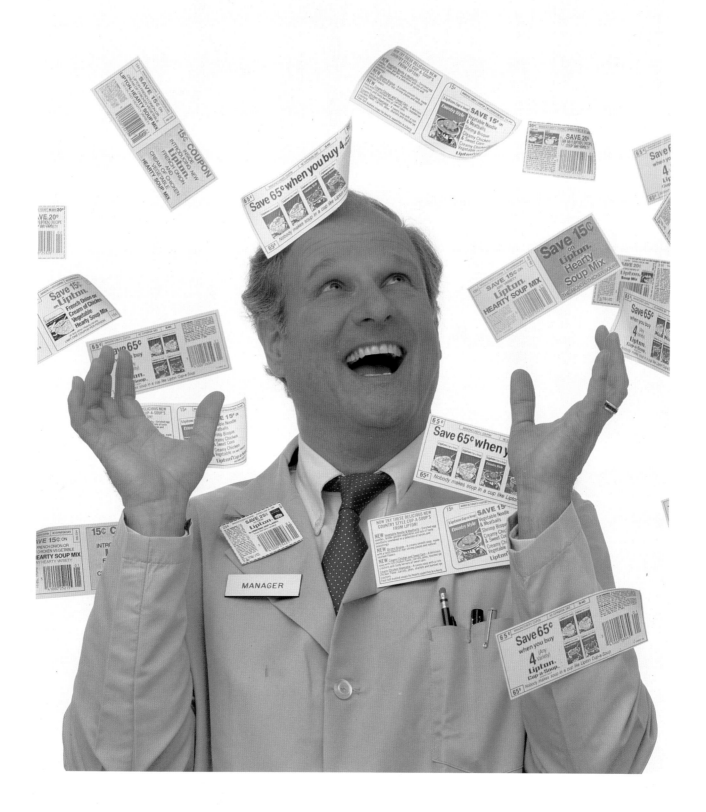

I did another set of rigging jobs for a series of ads for Chemical Bank. These rigging problems were a little harder in that the ad copy had to fit in a certain way, and there was a lot of copy. That part of the layout was nonnegotiable. But when I finished this series, I was very happy with the results. I managed to give every shot a feeling of motion, although nothing on any of the sets actually moved.

The first shot of the man throwing up his tax papers was done the same way as the Lipton shot, except that I used armature wire, which is available at sculpture supply stores and well-stocked art supply stores. Armature wire is great stuff—it comes in different gauges and it can be bent into any shape without losing its rigidity. I was able to use the armature wire, which does not disappear like monofilament, because the shot was black and white and was shot against white. It was very easy for a re-toucher to remove the wires that showed.

To rig the broken pencil, I had to make sure that the wire holding it together was shot while against the background and not against the model's shirt because it would have been harder to retouch the shirt. Against the white background, it would be easy. The model's tie was also attached to a piece of monofilament and clamped to a stand that was off camera.

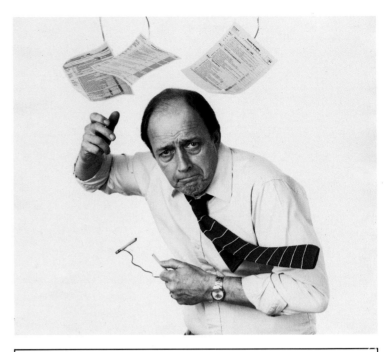

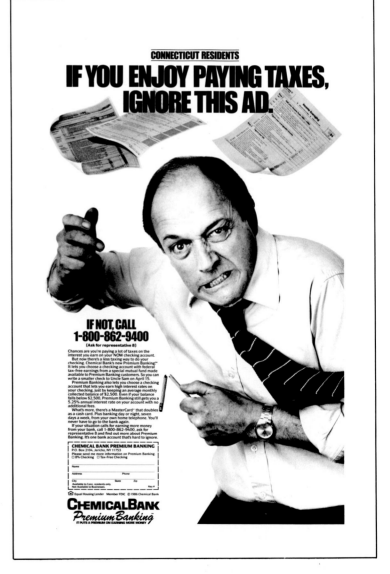

The man stopping suddenly with his hat falling off and his tie in the air turned out to be the hardest of the series. Although the basic layout was easy, his tie was just too long to fit into the layout. I attached a rope to a door and had the model hold on to the rope as he leaned back in a stool. His hat was wired to a stand that was removed later by retouching it. But the tie gave me all sorts of headaches. I finally cut it an inch below the knot. Then I stuffed the remaining piece of tie back into the knot.

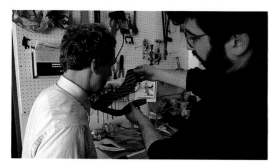

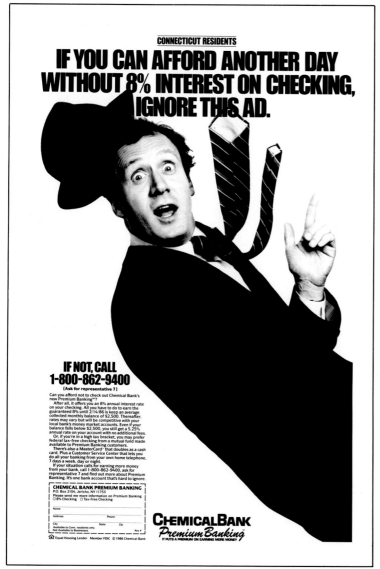

The picture of the woman running was made by wiring her purse to a floor stand off camera to the right. Her necklace was sustained in mid-air by two pieces of monofilament. A large wind machine was positioned off camera to the left in order to help create the illusion of motion. Putting the model's leg on a box raised it enough to make the viewer believe she was running.

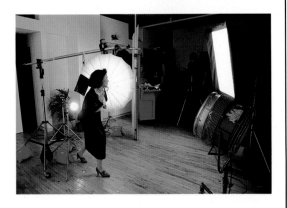

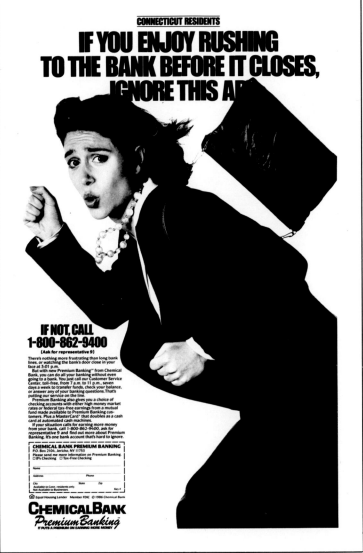

The NYNEX ad showing a businessman being picked up by a giant hand also depended on an illusion of movement. I put a piece of armature wire inside his tie to give it some body and shape, attached a piece of monofilament to the end of the tie, and tied it to a floor stand. Plastic bags, the kind the dry cleaner uses, were placed under his shoulders and vest to give his clothes some lift. The briefcase was gaffer-taped to a floor stand, and the papers and calculator were attached to armature wire secured to the inside of the case. If the viewer moved either left or right of the camera, the wires became visible. It was only in the camera's line of vision that they could not be seen.

I didn't shoot any other part of the ad; basically, on this job I was a hired gun. I had a problem to solve—making a man look like he was flying through the air, lifted by a hand that wasn't there—and I solved it.

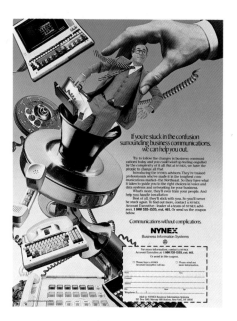

A MESMERIZING MIST

Aided by a smoke machine, I shot this apparition of a monk for a brochure about a book entitled *Strange Stories, Amazing Facts*. The story behind this picture is somewhat amazing, too. Joy Masoff was the art director, and when she drew her layout, she had the Cloisters, a medieval museum in New York City, in mind as the setting. But as we later found out, no photography is allowed inside the Cloisters, only outside. Unfortunately, the exterior didn't work for this shot, and so the search for a good location began. I looked at churches (including one that's now a disco called Limelight) as well as painted backdrops, but I couldn't find anything acceptable. Finally, Joy and I decided to have a backdrop custom painted. Using a backdrop didn't thrill either of us because we both felt the shot needed the realism that can only be found on location.

At the eleventh hour, Joy discovered a wonderful location at a church not far from her home in Pleasantville, New York. It was an outdoor walkway leading into a meeting room. Not wanting to leave anything to chance, I drove up to see if it was suitable for shooting. The walkway was perfect; its proportions

couldn't have been better. The ceiling was only about 8 feet, not 16 feet as I had feared. A high ceiling would have been much harder to light. And because the location was outside, I didn't have to worry about bringing exhaust fans to clear smoke from inside the building.

On the day of the shoot my assistants and I loaded a rented van with my camera and lighting equipment, lots of dry ice, and a state-of-the-art Rosco smoke machine. As we started off for Pleasantville, the van began to shake violently, so we had to turn around, get a new van, and reload it. When we finally arrived at the church, we set up two bare lightheads on the left side of the set, one to light the monk from behind and the other to light the wall. We put a third lighthead with a snoot on it up high and in front of the monk to act as a weak fill light. Once we were ready, I sent an assistant off to pick up Paul Renee, the model, at the train station. What should have been a five-minute trip turned into forty-five minutes because the van had a flat tire. This kind of problem gives location photographers gray hairs.

Meanwhile, my other assistant and I began experimenting with the dry ice and discovered that it wouldn't work because there was a slight wind blowing that disrupted the effect. The walkway actually acted like a wind tunnel. Now it was time to pull out our state-of-the-art smoke machine. We filled it with fog juice, plugged it in, and waited. And waited. No fog. A long-distance call to the dealer who had rented the machine to me revealed that the fuse was missing from the little black hole in the back. At this point gray-haired photographers begin pulling out their gray hairs, but being professionals we don't panic. I took a safety pin from my grip case and substituted it for the fuse. Then I grabbed a role of gaffer tape, my standard lifesaver, and taped the pin into position. Very carefully, I plugged in the smoke machine. Eureka! We had smoke at last.

I was able to get the shot as planned, but everybody had to dance for it. Because the wind was still kicking up, I needed every free hand, including the art director's, to hold up a 4 × 8-foot card and shield the set from the wind. The final picture was very satisfying to everyone. I can't always anticipate everything that will happen on a shoot, but if I don't lose my head, I can usually improvise my way out of any bad spot.

SHOOTING PHOTOMATICS FOR COMMERCIALS

A photomatic is not a new type of self-focusing camera, and it's not a dime-store photography booth, either. When an advertising agency wants to test a new commercial concept, the agency sometimes hires a still photographer to shoot the concept frame by frame. Chromes, or slides, from the resulting photomatic are transferred onto videotape. The tape is then edited complete with zooms, pans, dissolves, a soundtrack, a musical score, and an announcer. This test commercial is shown to audiences, and their responses are evaluated. If it tests well, the commercial is then reshot on motion picture film, sometimes with the same actors and locations. The photomatic that was shot by the photographer is never seen by the public. (TV commercials that consist of still images are entirely different.)

Why go to all this trouble? Why not just shoot the original spot on film stock? The reason is that a commercial produced as a photomatic will cost anywhere from 10 to 25 percent of a filmed commercial. Even though the actors photographed have to be members of the Screen Actors' Guild and sign a SAG contract for the photomatic, the photographer, who acts as a director and cameraman, and the crew do not have to belong to a guild or a union. A filmed commercial is a more complex and costly production. Still-camera setups can also be done a lot faster than a film setup. Because of these lower costs, an advertising agency and its client can test many more ideas to see what will work.

Photomatics are interesting and pose a different set of problems for the still photographer. The thought process involved is completely unlike that for shooting an ad. For openers, the photographer is given a storyboard instead of a layout. When shooting from a storyboard, I have to think like a film director, planning camera moves, scenes, and shooting out of sequence because of logistics. I can't shoot scene A, then scene B, and then scene A again because that's the sequence in the storyboard. I have to shoot all the A scenes, then all the B scenes, and so on. Because of the logistics of getting from one spot to another I may have to shoot the C scenes first, then the A scenes, then the D scenes. It is very important for me to be highly organized and to have someone marking off the frames of the storyboard, so that I don't miss one. During a hectic shooting schedule, that could be harder than it sounds.

Because the still shots are being combined onto a videotape, I have to be very sensitive to making sure the camera doesn't move at all during the shooting of a scene, or I will cause a "jump" during the videotaping of that scene. Since jumps are not cool, I have to make sure that the tripod is locked down and secure. Any and all shots of a scene from a particular camera position should be taken at once and the camera moved later for close-ups and views from different angles. A zoom lens is extremely helpful in shooting a photomatic because it enables the photographer to move in without moving the camera. (When still photographers begin to shoot movie film, one of the first habits to overcome is this practice of tying down the camera. Important as tying down a camera is in photomatics, film is a medium of movement, and the ability to move the camera during the filming of a scene is crucial.)

Most photomatics are shot on 35mm film because its horizontal format is similar to a TV screen's dimensions. Nikon makes a viewing screen for its cameras that has what is known as a "TV cutoff," which shows all the different dimensions of a TV screen, including a "title cutoff" and where the "safety" is. A title cutoff refers to the boundaries where copy can be safely situated on the screen without the first or last letter being cut off from any TV viewer's screen. The "safety" is the extra margin around the edges of the screen where the image is still needed to prevent individual scenes from cutting into blank space. Magazine ads that bleed off the page also require a safety margin for edges of the page that the printer trims. When the printer cuts the magazine, there may be as much as an 1/8-inch (0.4 cm) movement, so bleeds require at least a 1/4-inch (0.6 cm) margin of safety, if not more.

Many people are involved in the production of a photomatic. One preproduction meeting I attended included the following people: The client sent a brand manager, an assistant brand manger, and a commercial production manager. The advertising agency sent an account supervisor, an account executive, an assistant account executive, a cost analyst, an art director, a producer, a broadcast coordinator, and a copywriter. And in addition to me and my stylist, there was also a film editor for postproduction present. Photomatic meetings are somewhat informal but very professional. The storyboard is gone over frame by frame. At the end of such a meeting, everyone knows what is expected of him or her, when it is due, and what the commercial is trying to accomplish.

The storyboard for this Post Raisin Bran commercial showed a man sitting down and enjoying a bowl of the cereal. Meanwhile, nature begins to take over the kitchen behind him. A wheat field and grapevine overgrow his cabinets, and a moose, a rabbit, and various birds appear. Creating this photomatic involved building a realistic kitchen set as well as a wheat field that grew taller inch by inch. All of the animal props were stuffed except the rabbit, which was alive and required constant supervision on the set.

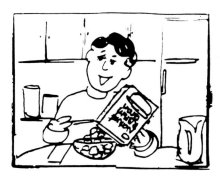

When you sit down to
Post Natural Raisin Bran...

at first, you won't notice
anything different.

The taste is still terrific.
But that's nothing new...

Those California raisins
are so naturally sweet

you won't notice Post said

bye-bye to the sugar coating.

You also won't notice that
there are no preservatives.

Those golden toasted whole wheat flakes
are crispy enough without 'em.

Post Natural Raisin Bran.

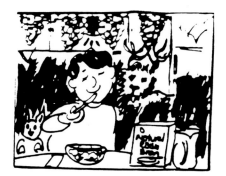

The only thing you may notice

is that somehow you might feel...
Well...

a little bit closer to nature.

These are the stylist's Polaroids of the kitchen cabinets I rented and the stuffed animals that she found at the taxidermist's. The stylist showed the Polaroids to me, and if I approved them I passed them on to the art director; if I didn't, she went out to find more props.

The wheat field was constructed by a model maker who arranged the wheat rows on "steps" to give the impression of distance. The steps also helped make the wheat look as if it were growing. As a result, the wheat field, which was just 4 feet deep by 8 feet wide (1.2 × 2.4 m), looked a lot deeper.

Along with the wheat field, the client wanted to have the vines hung with dried raisins. Since raisins dried on the vine are not that common, especially in Manhattan in April, the raisins on the vine had to be constructed. The model maker declined the job since it was Friday afternoon, the shoot was on Monday, and he already had plans for the weekend. I gave it some thought and came up with the idea of attaching the raisins with hot glue. I went to a fruit stand and bought several of the nicest looking bunches of grapes I could find. I then took the grapes off the stems and placed the stems in my oven to dry out. I thought grape stems would cook well at about 250°F for about fifteen to twenty minutes, and I was right. I then took a raisin, put on a small amount of glue from my hot glue gun, and placed the raisin on the end of a stem where a grape had previously hung. The hot glue took only about two seconds to set. So I spent my weekend at home watching old black-and-white movies on TV, while I glued raisins onto the stem. They looked great—unless someone knew I glued them, they looked real.

The photomatic for Post Raisin Bran took two days to photograph. The first morning was spent making sure that everything in the kitchen (excluding the wheat field) was in place and looked okay, that nothing was growing out of the model's head, or that none of the props were juxtaposed in a weird-looking way. The wheat field was then added to ensure that the actor had enough room without moving and that nothing on the kitchen set would have to be moved in order to get the wheat into position. Once everything was "locked" into position, I started shooting.

Since the wheat field was in position and it had taken my crew most of the morning to get final positions, I decided to start shooting the photomatic with the wheat field in place first and go in reverse sequence of the storyboard. I taped Polaroids on the storyboard as I went along to keep track of which frames of the storyboard were shot. It would have been very embarrassing to shoot for two days and find out at the end I had missed a frame. It is not as hard to miss one as one might think.

This photomatic was a little unusual in that the production house had requested for editing purposes that it be shot on 120mm instead of 35mm film. This was fine with me because I prefer shooting in a larger format. Since Hasselblad does not make a focusing screen with a TV cutoff, I made an acetate overlay with the TV cutoff drawn on it and taped it onto my focusing screen so that I could see where the cropping would be. I made a second acetate and placed it in a cardboard frame so that the art director and the producer could visualize the cropping when I gave them a Polaroid.

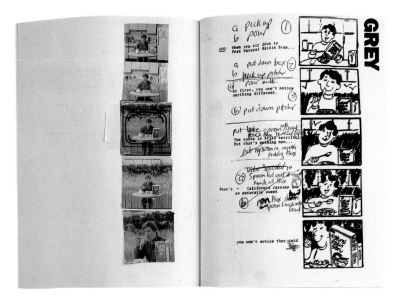

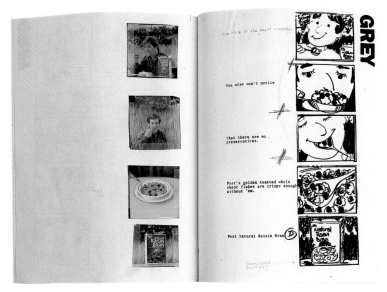

The shooting went quite smoothly, with people all doing their jobs but not the rabbit. He would sit fine for about a second and then try to hop off as fast as he could go. (The rabbit shown here was stuffed.) The moose head was mounted on a flat, which was secured with braces. It was huge and took three assistants to move it into each of the three positions.

On the final tape, the art director put more animals and birds in the wheat field. She was able to strip them in electronically from other chromes that I had shot. Modern technology is just amazing.

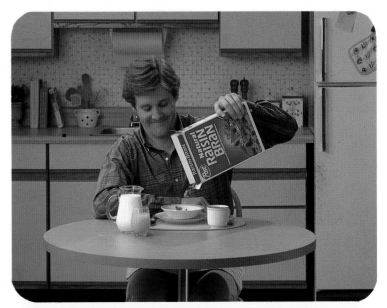

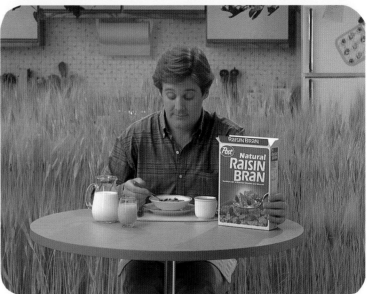

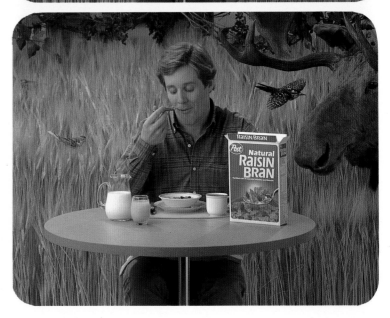

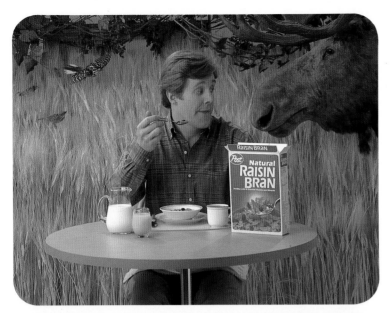

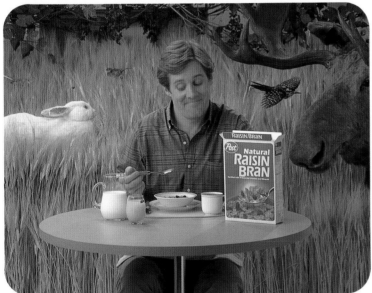

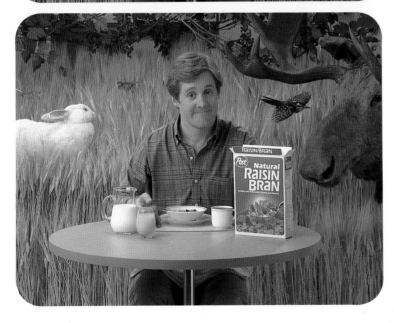

A GIGANTIC STILL LIFE

When I first got the layout for this shot of a truck from Eileen Walsh, an art director at Lord Geller Federico and Einstein agency, I thought it would be a very straightforward, no-problem shoot. The client was providing the crate and the art work that went on the crate. All I had to get was the truck and a studio to shoot it in. The studio I normally use for car shots was available the day I needed to shoot and was being held for me.

The only thing left for me to do was line up a Mitsubishi truck. Because of the concept of the ad, it had to be a Mitsubishi. There are several services in New York that locate cars and trucks in any make, color, or year. For some reason, I ran into problems here. What I thought would be the easiest part of the assignment began to look like an impossible task.

The staff at one of the services I called said they had already made a dozen calls to people they thought could help but had struck out. They told me they could get almost anything on two or four wheels, with the exception of a Mitsubishi truck. The second service's personnel I had working on it said, "No problem"; they were hot on the trail of a truck. They finally did come through, less than 24 hours from when I had to shoot in order to make all the ad placement deadlines. This kind of waiting is known as sweating bullets.

The truck this service located was red with black letters, which was not ideal, but I didn't have much of a choice at this time. Eileen cut out white letters to fit over the black ones. After the crew double-stick taped them over the black letters, they looked great. They popped right out at the viewer.

The only thing left to be done was to light the truck. If a photographer has never lit a truck before, it can prove to be quite an experience. This job went without a hitch, since I had done several vehicle shots before at this studio and knew where everything was located and how it worked. My assistants and I put up a paper "cyc" (an abbreviation for "cyclorama," a wall without seams or corners), lowered the two giant reflectors that were attached to pulleys in the real ceiling, and bounced our lights off them and several large reflectors on the ground. We also placed strobe heads inside the cab of the truck and into the truck bed to open up areas that were too dark.

Shooting any vehicle is like shooting a mirror; photographers have to keep in mind that anything and everything will reflect in the vehicle's body. Even when shooting cars and trucks outdoors, most photographers work during that short period of time after the sun goes below the horizon but before the sky becomes dark. This light lasts only a short time, so they have to be very well prepared. Shooting cars and trucks is like shooting a very large still life. It keeps me on my toes.

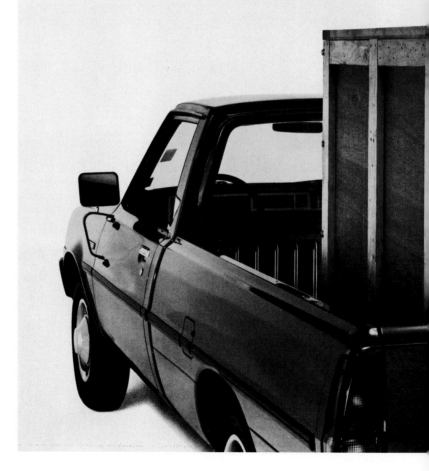

great truck.

...dustry format. With over 200 Sony systems in use, compatibility ...n't a problem, it's a plus.

But best of all, Sony equipment is famous for working right out ...f the box. So the quicker we get the box off the truck, the quicker you ...an be in business. **SONY**
PRO AUDIO

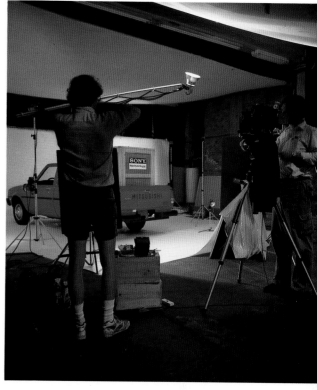

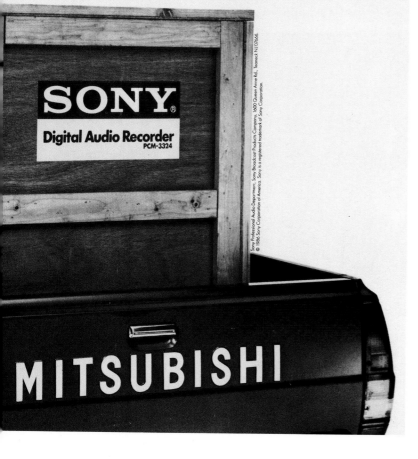

SONY®
Digital Audio Recorder
PCM-3324

MITSUBISHI

These pictures for Philadelphia's "We the People" celebration represent the kind of illustration work I most love to shoot: no product to sell in the shot, just an emotion to convey. The shooting was a pleasure from beginning to end. Best of all, all the people involved, from the art director to the models, were real pros. The art director, Michael Chauncy from Spiro Advertising in Philadelphia, is the type of art director I look forward to working with. After a few preliminary discussions, both Michael and I knew what we were looking for. He is a good communicator and was not vague about what he wanted in the shots. When he saw the Polaroids at the shooting, he made specific suggestions, not commands, and he did not try to cover the scene several different ways.

It's best to shoot variations of a scene whenever possible to avoid backing the art director into a corner when a final shot has to be chosen. Some art directors I've worked with have asked for so many variations that it's obvious they're trying to cover all the bases and second guess the creative directors back at the office, who are in turn trying to second guess the clients. I'd much rather work with an art director who has enough confidence in his or her concept to follow one direction and develop it fully.

Since I had never seen the Liberty Bell or Independence Hall (*mea culpa*), Michael had me visit both, so that I could plan the shots. Originally, when I was told that the Liberty Bell was in a large, glassed-in room, I thought I would put diffusion material on the glass and place lights behind it. On viewing the bell, I saw this would present several problems, such as getting a 15-foot (4.6 m) ladder or two to place the diffusion and compensating for the slight green cast that my color temperature meter told me was in the glass. The latter meant I would have to put magenta filters on the lights outside.

There was enough room behind the bell to run a white seamless background and light it. The ceiling was solid, not a drop ceiling, so I was able to use polecats with clamps, hooks, and a crossbar to hang the seamless paper. Using seamless instead of putting up diffusion material on the window saved us a lot of time. Timing is everything, as they say. I only had from 7 AM to 9 AM to set up, shoot the ad, pack up, and leave. When Independence Hall opened for the public at 9 AM, I had to be gone. The second shot, done later that day, was easier because I was able to set up at 5 PM when the building was closed and continue shooting as long as I wanted.

Before the day of the shoot I called the Parks Department electrician to go over what amperage I would need and what was available. I also called my insurance broker to have a copy of my insurance policy sent to the Parks Department official in charge of the bell and the hall. This is known as a certificate of insurance, and is made out to the people requesting to see the photographer's insurance coverage. In most cases, I do not need to take out any additional insurance, since the policy I have covers the million-dollar liability the Parks Department requires. This job involved another fun call to Jacob Schulhof, my insurance broker. "Hello, Jacob? I need coverage for the Liberty Bell. No, no, I promise we won't break the bell. Yes, yes, we won't try to fix what is broken. I won't even breathe on it, honest."

I arrived in Philadelphia the night before the shoot with my two assistants and checked into our hotel. A third local assistant was hired to help us set up and tear down, since time was critical on this shoot. I also like to hire a local assistant in towns I am not familiar with in case we need something on the spur of the moment.

At the hotel we ran into the celebration of the Army-Navy football game, held earlier that day. The place was packed with partying college students. This caused a lot of confusion. There was a 10-minute wait to go up in the elevators with our equipment. The first room I was assigned had clothes and toiletries scattered all around. Back down the incredibly slow elevators to get another room. It was pretty late by the time we were all settled. My room wasn't too bad, but one of my assistants, who was on another floor because of the room mix-ups, had an all-night party going on next door. He was a little groggy when we were called at 4:00 AM.

By 5:30 AM we had had breakfast and had loaded the van with the equipment. By 6:15 AM we were at the Liberty Bell. At 6:59 AM the electrician came to let us in. By 7:05 AM both models, the hair and makeup stylist, the art director, the agency head, and others were there. By 8:00 AM we were set to shoot. The seamless background was in place and lit. The strobe boxes, for some unknown reason, were not firing and were replaced with spares. The models had finished their makeup and dressing.

The lighting for this shot was set up to give a very open, clean, straightforward look. This was not the type of image for a dark or shadowy look. The seamless was lit with four strobe heads, two on each side. This created pure white behind the subjects and also threw some of the light around them. The lighting in front was fairly flat, open, and nondirectional. The main light was a 4 × 6-foot (1.2 × 1.8 m) horizontal bank directly over the camera. Two umbrellas on either side of the bank, set at half the power of the bank, provided a soft, over-all fill with no cross shadows. The umbrellas were not

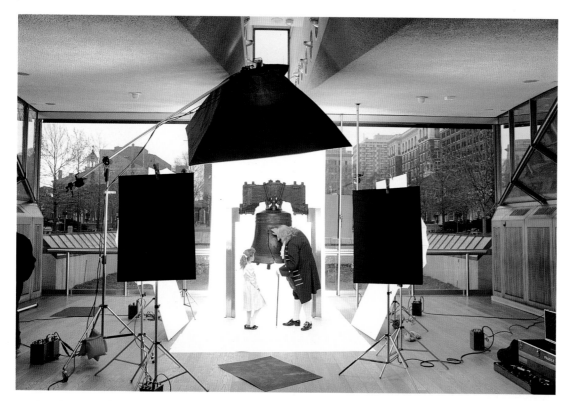

used to bounce the strobe lights; instead, the lights were shot through the umbrellas to keep the light soft.

I shot with a 150mm lens on a Hasselblad. The long lens flattened the perspective and drew the background—the bell in this case—into the foreground. This made the bell appear a little larger than it would have with a normal lens. A long focal-length lens makes the background larger, and a short focal-length lens makes the background smaller and farther away.

Ralph Archbold, the actor playing Ben Franklin, was just great. He had all his own wardrobe, including accessories such as a walking stick with the initials B.F., which he had found in an antique store in Philadelphia. He has made a career of portraying Ben Franklin, and was under contract to the City of Philadelphia to portray Franklin for the "We the People . . ." celebration.

Because of all his experience as a spokesperson he had a great rapport with children and was wonderful at putting the little girl, Marissa Lynn Putten Vink, at ease. This was a big help, since I wanted her to reach up to his tie while on her toes, keeping her head turned slightly to the camera so I wouldn't lose her face. Ralph was just a fountain of stories and information about Ben Franklin. His storytelling talent became a lot more important during the evening shoot, since there were three children in the shot. If the children in either shot had been uncomfortable with Ralph, it would have made the shootings a lot more difficult than they already were.

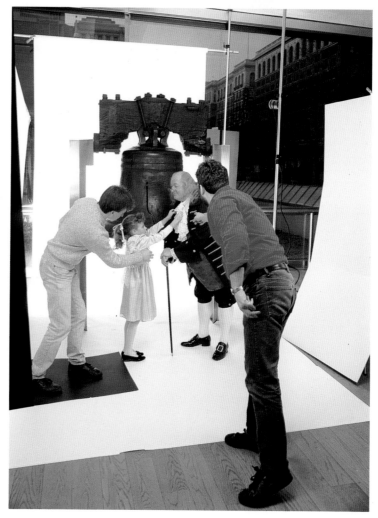

When I saw the size relationship between the models and the bell, I realized that I could take a separate shot of the bell by itself. The final image could then be made by stripping the two shots together, permitting the bell to be larger and taller in relation to the models than it was in real life. I took one of the Polaroids I'd made and cut it out around Ben and the little girl. I then made a second Polaroid of just the bell, moving my camera closer to make the bell larger. I had an acetate of the dimensions of the ad and the copy area of the ad Scotch-taped into my view-finder, so I knew how big I could make the bell and still have it fit into the ad. By placing the cut-out Polaroid on top of the Polaroid of the enlarged bell, I was able to show Michael how a larger bell would look behind Ben and the girl. Michael liked this look, so when there was a break in shooting for a wardrobe change for the little girl, I shot a roll of just the bell by itself. The posts supporting the bell were later removed by a retoucher.

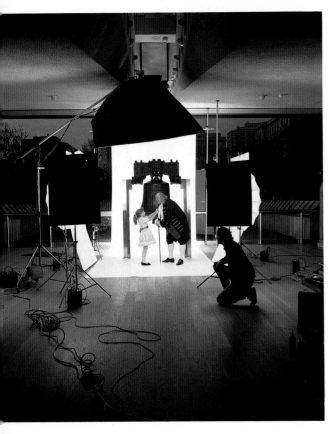

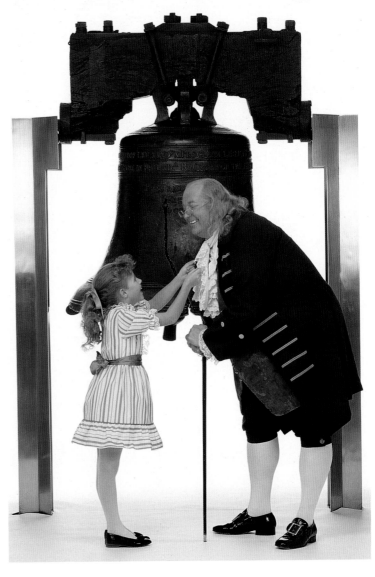

Celebrate America in Philadelphia.

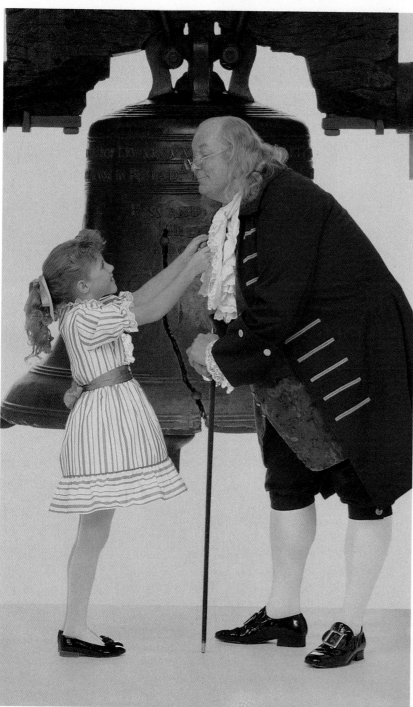

Come to Philadelphia and celebrate the 200th anniversary of the U.S. Constitution.

200 years ago, a miracle took place in Philadelphia. 55 delegates gathered at Independence Hall to forge the document that shaped our nation. Join us in 1987 as we commemorate that monumental event with We the People 200. A year-long pageant of special events. Fireworks. Festivities. Parades. Exhibitions. Famous guests. And all the thrills of one of America's most exciting cities.

A few of the many spectacular events: *All Roads Lead to Philadelphia,* May 22-25, the sensational kick-off tribute to the 13 original states. *Freedom Festival,* July 3-5, a rousing salute to America's independence. And *Constitution Day,* September 17, the largest parade ever assembled in the USA.

Throughout 1987, Philadelphia will buzz with activity every day and night. Come celebrate with us.

For a free Philadelphia Visitors Guide, We the People 200 Calendar of Events, and Hotel Package Brochure, call: **1-800-523-2004, ext. 87.**

P·H·I·L·A·D·E·L·P·H·I·A
Get to know us!

You've got a friend in Pennsylvania

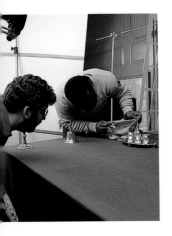

I finished the bell shot at 8:55 AM. At exactly 9:00 AM people started coming in to view the bell as my crew and I packed up our equipment off to one side. We were loaded into the van by 9:30 AM, drove back to the hotel for a quick unloading of the equipment and nap time. We all slept until 2:00 PM, when we met for lunch and discussed the morning shoot and went over what we would do for the afternoon shoot. After lunch we packed the van again, checked out of our rooms, and headed to Independence Hall for our 5:00 PM shoot.

The problem I faced with this shot was separating the people from the background in order to keep them from "melting" into the dark wall. Normally I would have used a backlight to give them an edge, but because of the physical arrangement of inkwell, table, chair, and wall, there was no room to place a light. I did have the Park Rangers assigned to help us move the tables as far forward as it would go, about another 6 inches (15.2 cm). We were not allowed to touch or move anything in the room. One of the Rangers was an historian, who made sure nothing was out of place.

The few extra inches gained by moving the table allowed me to put up a "window" frame on the left side and use an amber-gelled strobe head for sunlight. The window frame was made by cutting 6 × 8-inch (15.2 × 20.3 cm)-openings out of a piece of foamcore. This gave the illusion of a multipaned window, common in the colonial era. (If I were shooting a modern scene, I would cut horizontal slits in foamcore to create a Venetian-blind look.) This sunlit effect on the back wall gave me the slight separation I was looking for. Unlike the morning shoot, where I used a long focal-length lens to bring the background in closer, here I shot with a 50mm lens on a Hasselblad. The wide-angle lens also helped to create some distance between the subjects and the back wall.

I used tape measure and the depth-of-field scale on my lens to determine my focus. Once set, the lens can be taped so as to not move and shift focus unexpectedly. I sometimes will use Polaroid 665 P/N film that produces an instant negative, and then I view the Polaroid negative through a loupe to check my focus.

The afternoon shooting went as smoothly as the morning session. I had all the children repeating vowels—"A," "E," "I," "O," "U," which gave them something to do and something to say. They loosened up and looked as if they were all talking instead of just standing around like wooden Indians. At the same time I had the little boy on Ben's lap play a vocal "Simon Says . . ." with me. I would say something and he would repeat it. I was saying things like "fuzzy pickle" and "purple hippopotamus" in order to get him to laugh and look natural. Ralph Arch-

bold was again a great help. He was telling the children some great yarns, and for several rolls I shot what was before me, Ben Franklin telling a group of children a story. It looked very natural because it was; the children were listening very intently. My crew and I topped off a great day of shooting with a great culinary experience. We went out for a Philly cheese steak celebration.

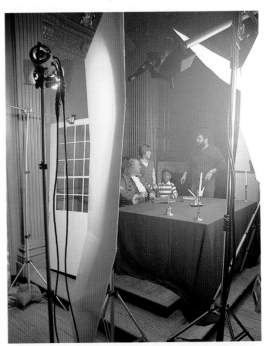

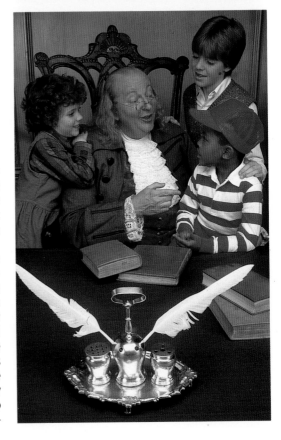

Share America's story in Philadelphia.

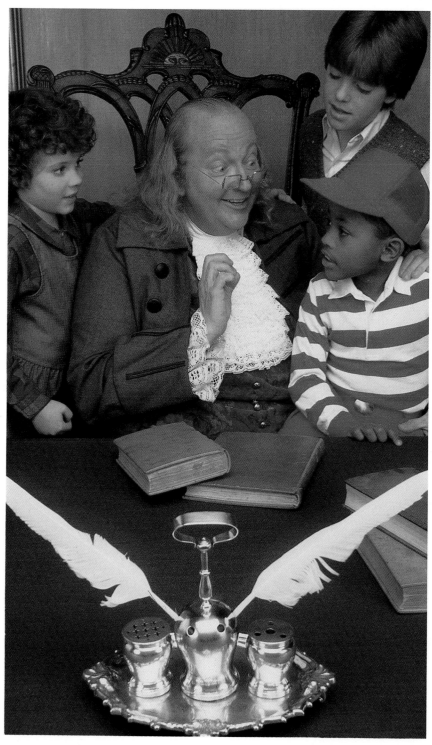

Come share in the celebration of the 200th anniversary of the U.S. Constitution.

200 years ago, a miracle took place in Philadelphia. 55 delegates gathered at Independence Hall to forge the document that shaped our nation. Join us in 1987 as we commemorate that monumental event with We the People 200. A year-long pageant of special events. Fireworks. Festivities. Parades. Exhibitions. Famous guests. And all the thrills of one of America's most historic cities.

A few of the many spectacular events: *All Roads Lead to Philadelphia,* May 22-25, the sensational kick-off tribute to the 13 original states. *Freedom Festival,* July 3-5, a rousing salute to America's independence. And *Constitution Day,* September 17, the largest parade ever assembled in the USA.

Throughout 1987, Philadelphia will buzz with activity every day and night. Come share in the celebration.

For a free Philadelphia Visitors Guide, We the People 200 Calendar of Events, and Hotel Package Brochure, call: **1-800-523-2004, ext. 87.**

P·H·I·L·A·D·E·L·P·H·I·A
Get to know us!

You've got a friend in Pennsylvania

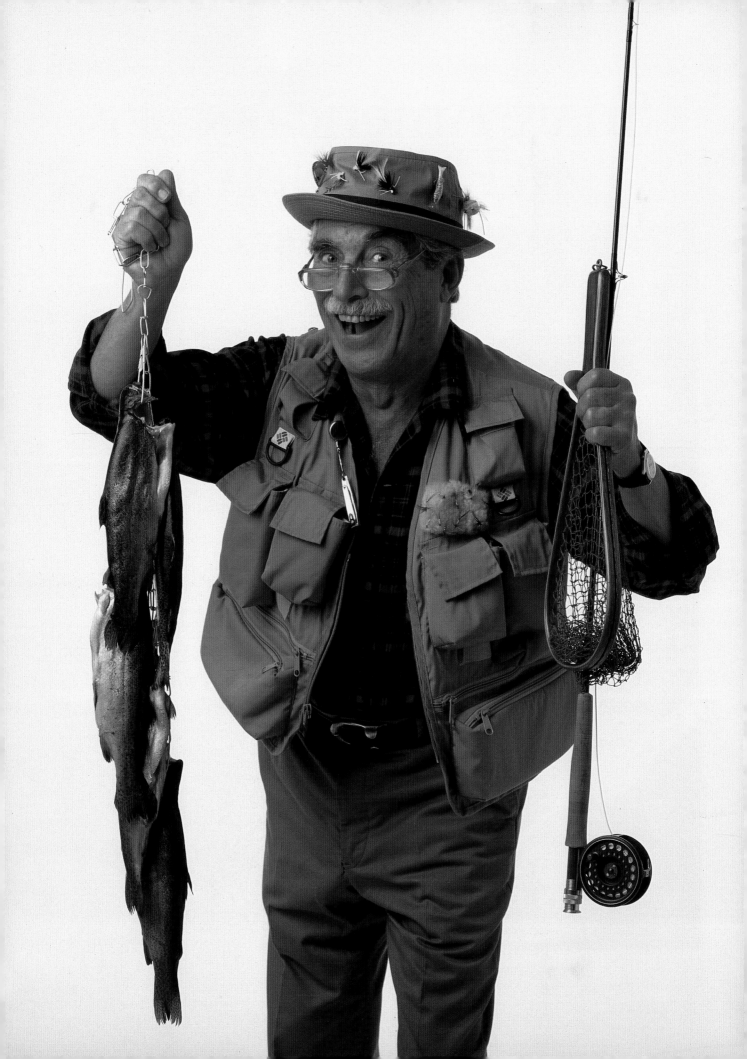

GETTING THE JOBS

If a photographer takes a photograph of a tree falling in the woods and no one sees the photo, does the photo exist? Not if he or she is a commercial photographer it doesn't. As a commercial photographer my goal is to have people see my work and to get more work, hopefully from art directors who are as creative and inspired as I am. If the art directors don't know that I exist, it's hard to get work from them. The world will not beat a path to my door simply because I'm a good photographer. People have to know who I am and where my door is.

Word-of-mouth recommendations are extremely important for establishing a reputation, but self-promotion has become the cornerstone of building professional recognition. My early promotions were not photographic; their purpose was to bring me instant name recognition, which they accomplished. If people know who I am, it makes it easier to get an appointment to show my portfolio. When someone asks, "Jack who?" I know making my pitch isn't going to be easy.

The first part of a good promotion campaign should start with the photographer's name. It can be simple or fancy, but the name has to be legible. I've seen many ads for photographers where the name is in a fancy script that takes a few minutes to read and decipher. This does not make for a memorable logo. My logo, "REZ-NICK-I," my last name spelled phonetically, has proven to be very im-portant to my business. The tag line in very small type, "Just call me Jack" that goes with my large logo appeals to and reflects my sense of humor. An art director at one large advertising agency couldn't remember my name but did remember my logo. He went to the art buyer at the agency and asked to see the portfolio of "the photographer who spells his name like a dictionary." My logo was conceived and designed by Marty Goldstein at *The Creative Black Book*, as one of the services it provides.

One of the first self-promotions I did that was not a card with a photo was a red cookie tin with my logo printed on top, filled with delicious, chocolate chip cookies, baked by Elyse Weissberg, who is my rep. We gave them out during Christmas to art buyers and art directors. They were such a big hit, that the following Christmas we gave out handmade Jack-in-the-boxes. They were another hit. After the second year, people were wondering what we were going to do next. It worked better for name recognition than sending out just picture cards, which we still do because people do want to see what I'm up to or what kind of work I do. I do want to be known for more than just sending out great promotion pieces. This last Christmas we sent out quarts of apple cider with a label that pictured Elyse and me as the "American Gothic" couple and advertised "Reznicki Vineyard's Apple Cider."

Rěz-nick-i
(Just call me Jack)

JACK REZNICKI STUDIO

*These are some of the promotional items
I've used to create name recognition for myself.*

APPLE·JACK'S
CIDER

REZNICKI VINEYA

(2 1 2) 9 2 5 - 0

REPRESENTED BY ELYSE WEISSBERG (212) 406 2566

Rĕz-nick-i
(Just call me Jack)

JACK REZNICKI ST

212 473 0913

It's important that self-promotion be a well-thought-out campaign, not just a shotgun approach. It is very easy to sit down at the beginning of the year and map out the whole year's promotion. I schedule when cards will go out; for example, I do not necessarily want to send out cards during the Christmas blitz. Elyse and I figure we will send four to six mailers a year, and we time them to go when the promotion books that I advertise in, such as *The Creative Black Book* and *American Showcase*, come out. Also during the summer months of July and August, when many of the art directors are on vacation, we may or may not send out a card.

I send out the type of images I would like to shoot. Generally what one casts out is what one reels in. Sending out photographs of children will not bring in liquor accounts. If I've shot a campaign or ad that's been run a lot in national maga-zines, it's good for me to send out a promotional card on it so art directors will know I was the photographer. If I've shot an ad that's not a national ad and was not seen by a lot of people, I may send it to such advertising trade magazines as *Art Direction* or *Photo Design*. If they run it, I've gained myself a lot of free publicity.

I've also had T-shirts and buttons printed. I give them to messengers, secretaries, art directors, and anyone who will take them. I'm a firm believer in utilizing any and all forms of promotion, not strictly photo cards. One photographer I know used to say he didn't care what pictures were sent out as long as his name was big, so that when the art directors threw them into the trash, they saw the name. Another photographer, J. Brian King in Miami, has one of the greatest promotional T-shirts around. It reads, "One picture is worth three thousand dollars plus expenses."

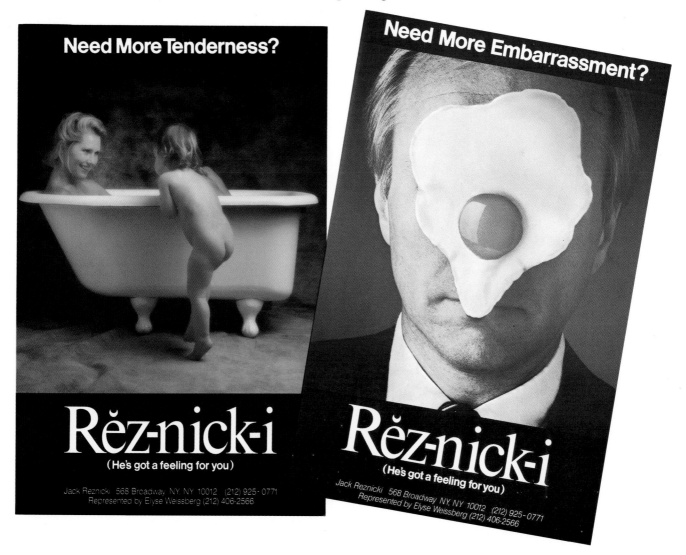

Jack Reznicki
568 Broadway
New York, New York 10012
(212) 925-0771

Represented by: Elyse Weissberg
(212) 406-2566

People Photography: Location and Studio

Clients include: Crest, Panasonic, Timex, Wrangler,
STP, Corning, Personna, Old Milwaukee Beer, Stroh's
Beer, Readers' Digest, NY Telephone, NYNEX,
Cincinnati Bell, Manufacturers Hanover Trust, Irving
Trust, Playboy, Tic Tac, Binaca, Foster-Wheeler.

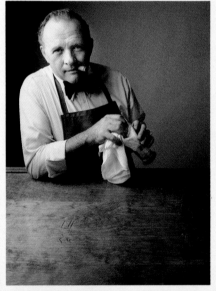

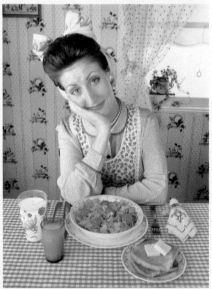

Rěz-nick-i
(Just call me Jack).

Printed in Japan ©1986 American Showcase, Inc.

Many photographers ask me how a particular mailing or book ad did for me. I find this a hard question to answer in that I believe everything I do works in combination. Very few art directors will give a photographer work the first time around. They may want to see his or her work over a period of time. This may include a portfolio, mailers, and book ads. After a while they get to know the person's work and style. A lot of the work I get is from mailers or book ads that are several years old. An art director will call up for a job and say that he has my card of such and such and is calling me for an ad with a similar feel. Sometimes it's a card I mailed out a year earlier. However, it's still a great feeling when I get a job from an art director from a mailing I sent out just two weeks before.

So what works best? A little of this and a little of that, a dash of luck in timing, and some time to let it all simmer. It's very hard to expect work from just one mailer sent out at a bad time. The worst thing to do is put off doing a mailer. A photographer can always find an excuse not to send one waiting for a better shot, a better time, a better printer. The impor-
tant thing is to get started. An invisible photographer doesn't get jobs.

My portfolio is not just another promotional tool, it is my most important tool in acquiring more work. When I send out a successful mailer, the response I normally get is not a call to do a job, but rather a call to see my portfolio. It has to reflect the type of work I'm best at and also back up the type of work I'm sending out in my promotions. It would be silly for me to send out a fashion photograph if it were the only good fashion piece I had. My portfolio has to back up my promotion. A one-of-a-kind, gorgeous photograph that does not relate to the other pieces in my portfolio is not the photo to send out as a mailer. Those one-of-a-kind-photos, or photos of something I would like to do more of, are the pieces I include in my portfolio to art directors who have seen my work many times before or who have worked with me. They are very familiar with my work and my style and can understand different pieces in my portfolio. A new art director who is not familiar with my portfolio would most likely be confused by a few photos that are different from the rest.

On the opposite page is one of my ads from American Showcase, *and below are three of my ads from* The Creative Black Book.

How do I get new pieces for my portfolio? Two ways. Testing and more testing. Most models are more than willing to work with photographers for free and will even help in getting wardrobe and props, in exchange for photographs for their portfolios. Models, like photographers, also have to display in their portfolios the kind of work they want to do. A model who wants work as a young mother does not show fashion shots; she needs young-mom shots. Most modeling agencies will gladly send models who are in need of photos for testing, but young photographers just starting out should expect the modeling agency to want to look at their portfolios to see what kind of work they do and at what level.

The Mr. and Mrs. Santa Claus shot was done as a test for myself. It was a lot of fun to produce and shoot, since there were none of the pressures associated with an advertising assignment. There was no format to follow, no space to leave open for copy, no committee of six behind me discussing if a red ribbon on the panties was appropriate.

Another way I acquire new pieces for my portfolio is to have the models at a job stay after their paid booking to shoot something without the product or a different idea using the same props and wardrobe. Almost all the models I ask are more than willing to stay, in order to get a photo for their portfolios. This is how I got the shot of the married couple arguing. Originally they were shot as a couple looking at a book, an almanac, for Reader's Digest. The ads for the almanac were done with art director Joy Masoff, who had come up with a great concept of different people settling their arguments with the almanac—two sports fans, two politicians, a married couple, and so on. Joy has given me some of my favorite assignments over the years, and this one was both figuratively and literally a scream. Since I had worked several times before with these models, Bobbie Fields and Ruth Williamson, I knew they were both fine professional actors and I thought we could have some fun with the characters they played. As a result, both the models and I got photos we could use in our own portfolios.

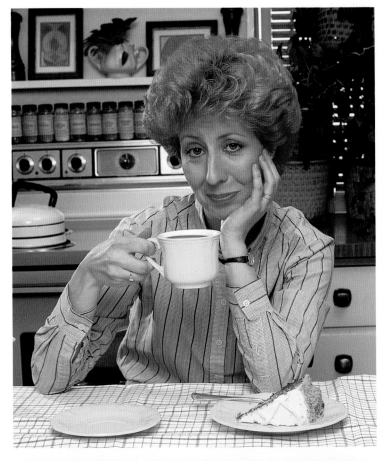

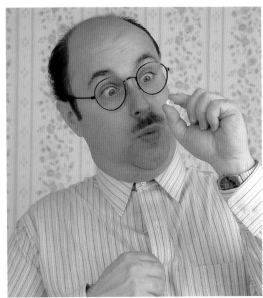

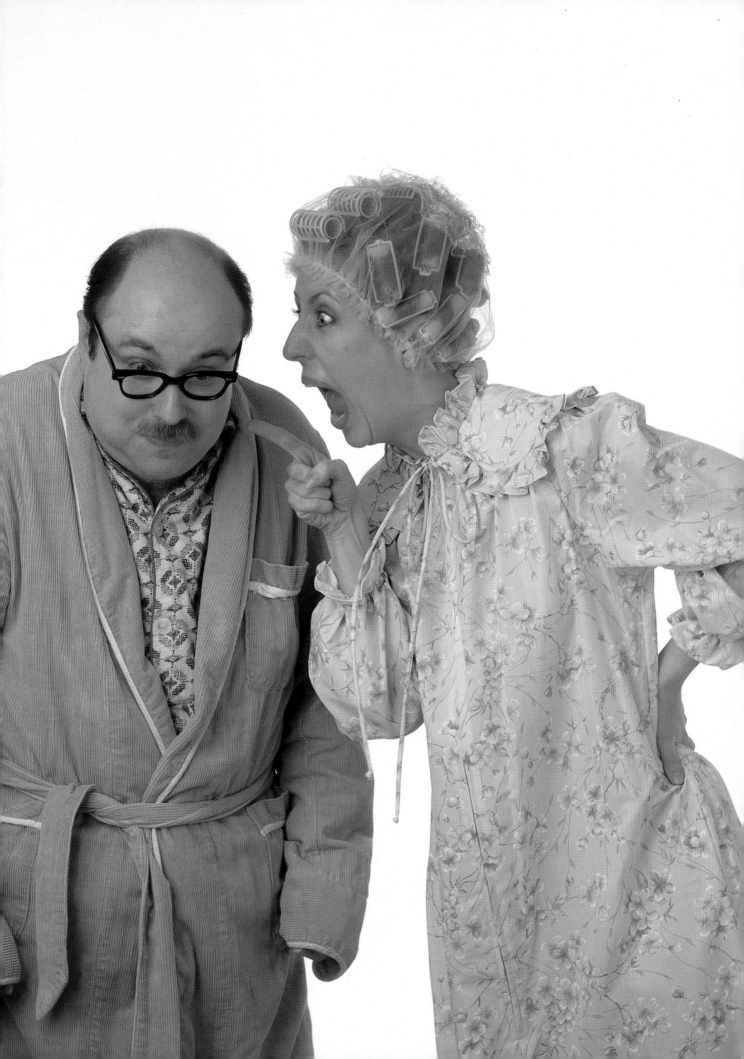

Some of the pieces in my portfolio were acquired by changing film type at a job. For example, the shot of the bartender was originally a color shot, but I shot a few rolls in black and white and those are the ones I show in my portfolio. I found the black-and-white photos had more impact and drama than the color shots, although the color shots were also good.

On the other end of the spectrum, so to speak, is the shot of the rock-and-roller. Originally it was shot in black and white for the newspaper ad for Sony shown on page 68. The lighting was set up for black and white and for newspaper reproduction. Because newspapers print with only a limited range of tones, the lighting for news photos has to be a little more open than the lighting for black-and-white magazine ads. Magazines can hold more tones, so the shadow details will not fill in as fast as they do in newspapers, and the photos, consequently need not be as open. If I had used the same lighting for color that I did for newspaper reproduction, the color would look too flat. So I asked the model, Eddie, if he would stay after the booking so I could reset the lights and cover the scene in color for myself.

Photographers who are just starting out can really benefit from such opportunities to expand their portfolios. Once a photographer has a great portfolio and a wonderful promotion campaign, the phone should start ringing with interested clients. Then the portfolio goes out, and lo and behold, a layout—a blueprint for another Potëmkin village—is delivered to the photographer's studio. To all future illustration photographers, I say, "Happy building."

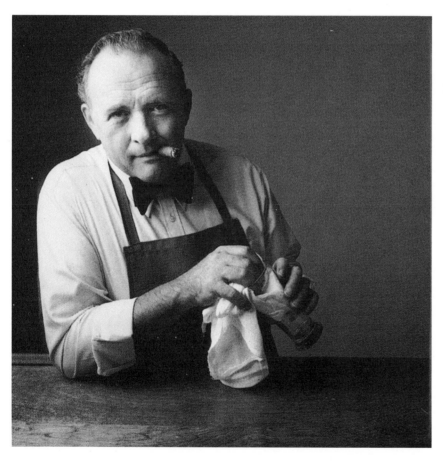

INDEX

ACKNOWLEDGMENTS

These abbreviations are used in the following list of acknowledgments:

AD—art director
AFA—Animals for Advertising
ASST—assistant
BB—Better Bodies
BK—Bookers
FF—Funnyface
GL—Gilchrist Models
GR—Gilla Roos Models
JL—Joanna Lawrence Agency
JN—Johnston Agency
MCD—McDonald/Richards Models
RL—Rogers & Lerman

Page i: Ruth Williamson, FF. Pages ii, iii: Bamboo the dog, AFA; Derick Utterback, FF; Harry Mann, FF; Alex Molina, GR; Joanne Ritchie, FF; Michael Tomlinson, FF; John Chappell, FF; Stephanie Silverman, FF; Tom Terwilliger, BB; Gary Kotz, GR; Lynn Killmeyer, FF; Rafael Andujar. Page vi: Joanne Ritchie, FF; Bea Boyle, GR; Wayne Jones, FF. Page viii: Wayne Gordy, GR; Veronica Blackwell, FF; Jamal Dean Lewis, GR; Ronnette Bouy, GR; Tom Fitzsimmons, MCD; Joanna Beckson, FF; Don Modie, FF; Barbara McKay, MCD; Geoffrey Grabenhorst, MCD; Gary Kotz, GR; Suzanne Lanni, GR; Billy Thompson, GR; Tracy Redwood, GR; Greg Connolly, GR; Jack Rich, BK; Claudia Martin, GR; Greg Fellows, FF; Tom Tully; Joanne Beckson, FF; Bobby Fields, FF; Ruth Williamson, FF; Frank Melfo, GR. Page 11: Loretta Tupper, FF. Page 14: Joanne Ritchie, FF; Tyler Jontz, FF; Cathy Lake, ASST; Joe Polillio, ASST. Page 17: Susan Leahy, MCD; Arne Gunderson, GR; Nina Mann, FF; Kurt Schmitt, FF; Renee Potts, FF. Pages 18-19: Mary Mayotte, JN; John Shaw, MCD. Page 20: Barbara McKay, MCD; Scott Bigham, MCD. Page 21: Wayne Jones, FF; Louise Elm, AD; Ted Bates Advertising/NY. Page 22: Maria Bag, JL; Ellsworth Benson, JL; Barbara Fields, JL; Jake Marshall, JL; Lou Scolnik; Laura Wamrone. Page 23: Eileen Winnick, JL; Robert Dutruch, ASST; Joy Masoff, AD. Page 24: Tom Fitzsimmons, MCD. Pages 30-31: DFS-Dorland, courtesy of Wrangler Jeans.

Page 32: Jacquelin Scott, RL. Pages 34-35: Mary Mayotte, JN; John Shaw, MCD. Page 45: Bruce Wodder, ASST; Barbara McKay, MCD; Tom Fitzsimmons, MCD. Page 46: George Corbellini, AD; courtesy of Reader's Digest. Page 48: Joe Jamrog, FF; Pegge Winslow, GR; Frank Deal, FF; Robin Rich, GR; Tara Metzger, FF. Pages 52-53: Barbara McKay, MCD; Paul Omin, AD; courtesy of Reader's Digest. Page 54: Anthony Means, FF; Mary Mayotte, JN; John Shaw, MCD; Bobbie Jones, MCD; Ben Short, MCD; Arthur Hill; Frank Melfo, GR; Pat Doyle, RL. Page 56: Varney Evans, GR; Robert Rigamonti, GR; Barbara Duff, GR; Molly, GR; Annette Mauer, GR; Frank Melfo, GR; Susan Gardner, AD; courtesy of Reader's Digest. Page 58: George Howard, FF; Don Modie, FF; Loretta Tupper, FF; George Wolf, GR; Mary McTigue, GR. Page 59: Richard Levenson, executive creative director; Hal Nankin, AD; Alan Barcus, copywriter; D'Arcy Masius Benton & Bowles. Page 60: Stephanie Silverman, FF. Page 61: Robert Rigamonti, GR; Barbara Nicole, FF. Page 62: Leslie Barrett, FF. Page 63: Jerry McGee, FF; Veronica Blackwell, FF. Page 64: Dyrall Latter, FF. Page 66: Ed Grimes, FF. Pages 66, 68, 120: Willoughby Meyns, account executive; Dick Thomas, creative director; Eileen Walsh, AD; Lord, Geller, Federico, Einstein; Sony Communications Products Co. Page 68: Eddie "Horror" Hruz. Page 70: Zoya Leporska, FF. Page 73: Carrie Jacobus, FF; Cheryl Simone Harrison, FF; Andrea Palmieri, GR; Joshua Faulkner, GR; Gregory Scott Carter, FF. Pages 74-75: Brian Barker, FF; Derick Utterback, FF; Kurt Schmitt, FF. Page 77: courtesy of American Baby, Inc., Pat Calderon. Page 78: Eric and Rick Van Valkenburg; Joanne Ritchie, FF; Fred Smith, GR; Ryan Mackie, GR. Page 79: Don Modie, FF. Page 80: Mary McTigue, GR; Don Modie, FF; Marissa Lynn Putten Vink, FF; Jamie Bailey, GR; Bobbie Fields, FF; Lois Ross, FF; Don Modie, FF; Miranda Knaub, FF; Anita Bayless, GR; Carol Bradley, GR. Page 81: Danny Des Jardin, GL. Page 82:

Robert Rigamonti, GR. Page 87: Valerie Marsch, GR; Marilyn Davis, AD; Vicky Faitell, design and layout; William Winters, copy; courtesy of Wolf. Page 88: courtesy of Foster Wheeler Corp. Page 89: Jan Leighton, FF. Page 90: Kelly Futerer; Martin Schaus, AD; Keiler Advertising; courtesy of Westvaco Corp., Envelope Division. Page 92: Virginia Davis. Page 93: Joy Masoff, AD; courtesy of Reader's Digest. Page 94: Jack Swanson, GR. Page 95: Steve Walsh, designer; Don Slater, AD; Adam Haft, copywriter; Slater, Haft, Martin. Page 96: courtesy of American Reinsurance. Page 99: Marezio Banazo, FF; Richard Ross, FF; Bill Lingo, FF. Page 101: Norma Villafana, AD; Jonathan Crane, creative director; Debbie Manser, VP marketing; Jameson Advertising; courtesy of Kepner Tregoe. Page 102: Rafael Andujar. Page 104, Tom Tully. Page 106-107: Joe Jamrog, FF; Doug MacGibbon, AD; The Task Group; courtesy of TJ Lipton, Inc. Page 108: Alan Leach, GR. Page 109: Don Modie, FF. Page 110: Judy Berman, GR. Pages 108-110: Joe Coccaro, VP Creative/AD; Jim Colasurdo, copywriter; Ketchum Communications. Page 111: Robert Rigamonti, GR. Pages 112-113: Paul Renee, FF. Pages 115-119: Randi Chasin, AD; Bob Skollar, creative director; Barbara Novak, copywriter; Jan Koblitz, creative supresvior; Grey Advertising. Pages 123-125: Marisa Lynn Putten Vink, FF; Ralph Archbold. Pages 126-127: Ralph Archbold; Carrie Jacobus, FF; Efrain Reyes, GR; Ryan Mackie, GR. Pages 125, 127: Michael Chauncy, AD; Robert Lesnick; Spiro Advertising; courtesy of Philadelphia Convention and Visitors' Bureau. Page 128: Bert Linder, FF. Page 136: Ann Carton, FF; Richard Bassett, FF; Miranda Knaub, FF; girl with fads courtesy off *Success!* magazine; Patricia Cadley, picture editor; David Bayer, AD. Page 137: Anita Bayless, GR; Bill Loma. Page 138: Bobby Fields, FF; Ruth Williamson, FF; Vincent Neil, GR. Page 139: Bobby Fields, FF; Ruth Williamson, FF. Page 140: Eddie "Horror" Hruz, GR. Page 141: Jack Lotz, FF.